A GUIDE *TO* HISTORIC

Charlottesville
&
Albemarle County
VIRGINIA

A **GUIDE** *TO* **HISTORIC**
Charlottesville
&
Albemarle County
VIRGINIA

JEAN L. COOPER

THE
History
PRESS

Published by The History Press
Charleston, SC 29403
www.historypress.net

Front cover: Albemarle County Courthouse, Charlottesville, Virginia, circa 1920
(American News Co.). *Collection of J. Tracy Walker III, Charlottesville, Virginia.*
Back cover: Martha Jefferson Hospital, Charlottesville, Virginia, 1914.
Collection of J. Tracy Walker III, Charlottesville, Virginia.

First published 2007

Manufactured in the United States

ISBN 978.1.59629.173.7

Library of Congress Cataloging-in-Publication Data

Cooper, Jean L.
A guide to historic Charlottesville and Albemarle County, Virginia / Jean
L. Cooper.
p. cm.
Includes bibliographic references.
ISBN-13: 978-1-59629-173-7 (alk. paper)
1. Charlottesville (Va.)--Tours. 2. Albemarle County (Va.)--Tours. 3.
Charlottesville (Va.)--History. 4. Albemarle County (Va.)--History. 5.
Albemarle County (Va.)--History, Local. 6. Historic sites--Virginia--
Charlottesville--Guidebooks. 7. Historic buildings--Virginia--Charlottesville-
-Guidebooks. 8. Historic sites--Virginia--Albemarle County--Guidebooks. 9.
Historic buildings--Virginia--Albemarle County--Guidebooks. I. Title.
F234.C47C66 2007
917.55'480444--dc22
2007019527

Contents

Introduction 7

1 Colonial Virginia (1607–1700) 13

2 The Settling of Central Virginia (1700–1775) 22

3 Central Virginia in the Revolution (1775–1783) 53

4 The New American Republic in Central Virginia (1783–1860) 77

5 Central Virginia and the War Between the States (1860–1865) 107

6 Charlottesville and Albemarle County in Post-bellum Virginia (1865–1925) 120

Notes 137

Introduction

My native State is endeared to me by every tie which can attach the human heart.

—Thomas Jefferson

Every day I drive to work down Virginia's Route 53. I pass the turnoff to Ash Lawn–Highlands, the home of President James Monroe. I drive by Colle, where Phillip Mazzei planted the first vineyard in central Virginia. I pass Monticello, Jefferson's home on the mountain, and go through Thoroughfare Gap, the only crossing in the central range of the Southwest Mountains. Then I drive up Route 20, originally called the Secretary's Mill Road, past the site of the old Blue Ridge Hospital, built in the early twentieth century as a tuberculosis sanitarium.

My alternate route is down Milton Road to the bridge across the Rivanna River, the site of the town of Milton, a shipping center that in the early nineteenth century was larger and more prosperous than Charlottesville, the county seat. Crossing the bridge, I turn left onto Route 250, a road that was built in the 1930s to replace the Three Notch'd Road. This is a route based on a Native American trail that has been used for several hundred years to get from Richmond to the Blue Ridge Mountains. As I go west, I pass Keswick, with its lovely old farms, some of which date from the eighteenth century; Edgehill Plantation, once owned by Thomas Mann Randolph Jr., a governor of Virginia and son-in-law of Thomas Jefferson; and Shadwell, the plantation on which Jefferson was born in 1743. As I crest the hill at Pantops, once owned and named by Jefferson, I am reminded why Jefferson named it "Pant-Ops" or "All Seeing": from the top of this ridge, there is a breathtaking panoramic view of Charlottesville, with the Blue Ridge Mountains beyond.

Central Virginia is one of the most beautiful and historic areas in the Commonwealth of Virginia, and every day, no matter which route I take, I am grateful for the opportunity to live here. The history of Virginia can be viewed through many lenses—cultural, ethnic, geographical and political. Because I am not a native-born Virginian, I did not learn about this history as a child, but have come to it fresh,

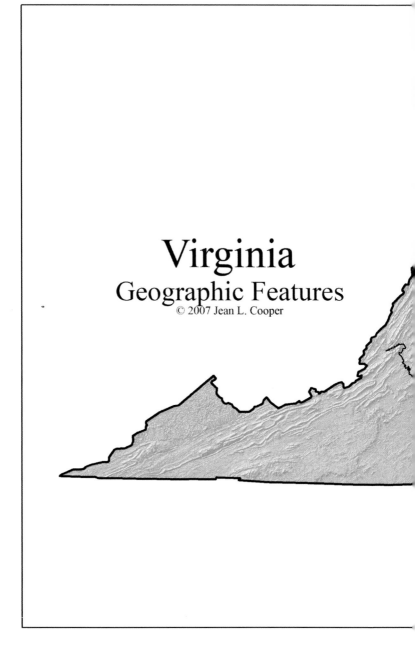

Map of the Commonwealth of Virginia, showing the Coastal Plains and Piedmont areas separated by the fall line, 2007. *Author's collection*.

A gift for you

From Katie & Chris

amazon Gift Receipt

Send a Thank You Note

You can learn more about your gift or start a return here too.

Scan using the Amazon app or visit
http://a.co/1wZ11zw

A Guide to Historic Charlottesville & Albemarle County, Virginia (History & Guide)

Order ID: 111-9962334-7805066 Ordered on May 26, 2019

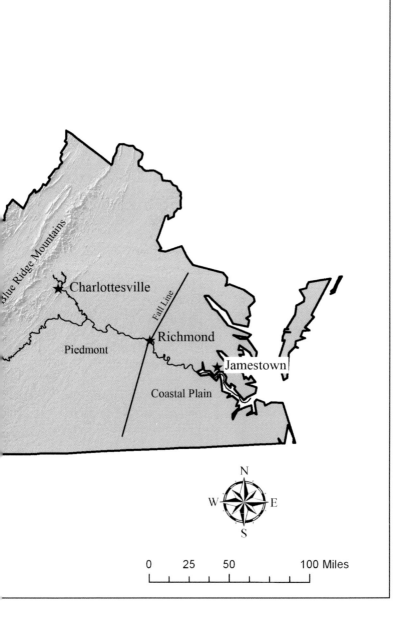

with the eyes of an adult. I have written this book to share what I have learned with newcomers and visitors, and I hope I have captured the essence of this place for you.

This guidebook offers an in-depth look at Albemarle County history. I've opted not to concentrate on the "big four" of central Virginia—Monticello, Ash Lawn–Highlands, Montpelier and the Rotunda of the University of Virginia. There are many books about those sites that discuss them in great detail. My intention is to introduce some of the lesser-known places of historical interest in the area. To me, history is all about context, and the historical overviews at the beginning of each chapter attempt to put the sites into context for the reader. The tours in this guide are loosely organized by historical period, and you can see them at your own pace, taking one day or several days for some areas.

I have received the help and support of many colleagues and friends—even friends I'd never met before—in writing this book. I have been privileged to use the collections of three libraries: the Albemarle Charlottesville Historical Society (ACHS) Library, the Jefferson Library at Kenwood and the University of Virginia Library. I offer my sincere thanks to Margaret M. O'Bryant (ACHS), Jack Robertson and his staff (Jefferson Library) and the staff of the University Library for their assistance in my research. I especially wish to thank my colleagues, C. Jared Loewenstein and Sara Lee Barnes, for their help and encouragement while I was researching and writing, and Chris Gist, of the University Library Scholars' Lab, for his help in mapmaking. I am grateful to Connie Geary of the Scottsville Museum and to Anne Shirley Bruce Dorrier, a lifelong resident of Scottsville, for their gracious help on matters Scottsvillian. Mr. J. Tracy Walker III allowed me the run of his collection of early postcards for illustrations, and I send him heartfelt thanks for his generosity. Last, but not least, I wish to thank the people who read and critiqued my manuscript, and discussed it with me *ad infinitum*—my sister, Jennifer Keels, and my friend, Rebecca Gilliam.

I hope you will enjoy reading and using this book as much as I have enjoyed writing it!

Note to the reader: Much of Virginia's history has been determined by the geography of the state. In general, the regions that will interest us are the Coastal Plain, which extends west from the coastline to the fall line (marked by the falls of the James and Rappahannock Rivers), and the Piedmont, which lies between the fall line and the Blue Ridge Mountains.

ABBREVIATIONS

NRHP–National Register of Historic Places (http://www.cr.nps.gov/nr/)

VLR–Virginia Landmarks Register (http://www.dhr.virginia.gov/registers/register.htm)

WHL–World Heritage List (http://whc.unesco.org/en/list/)

USEFUL VIRGINIA WEBSITES

Albemarle County Official Website (http://www.albemarle.org/)—Contains information for residents and visitors.

Charlottesville Official Website (http://www.charlottesville.org/)—Contains information for residents and visitors.

Charlottesville and Albemarle County Community Website (http://avenue.org/)—Lists events, local organizations and entertainment opportunities in the area.

Historic Garden Week in Virginia (http://www.vagardenweek.org/)—During April each year, the Garden Club of Virginia offers house and garden tours of historic Virginia properties, some of which are only open during this event. Advance ticket purchase required.

University of Virginia (http://www.virginia.edu)—Guide to sites and events at the University of Virginia.

Virginia Department of Transportation (http://www.virginiadot.org/)—In addition to providing weather and road work alerts, you can order a free State Transportation map, a Virginia Byways map and a Bicycling in Virginia map.

Virginia Tourism Board Official Website (http://www.virginia.org/)—Includes schedules of events in the state by date, by region and by theme.

Virginia Wine (http://www.virginiawines.org/)—This website has a complete list of vineyards in Virginia, along with regional maps and information on wine festivals throughout the year.

Chapter 1

Colonial Virginia (1607–1700)

W hat happened at Jamestown during nearly one hundred years of tumultuous history laid the foundation for events and actions of the American nation and people for the next four hundred years. The English colonists' treatment of the Virginia Indians foreshadowed American treatment of Indians across the continent. Tobacco cultivation encouraged the plantation system and an economic dependence on slavery to support that system. The need for new land on which to plant tobacco began the westward expansion that would last through the end of the nineteenth century. The triumvirate of the royal governor, the Council of State and the House of Burgesses—the beginnings of representative government and a system of checks and balances—formed the political thought of the founding fathers and served as the model for the government of the United States.

Most of all, Jamestown represents, if anything can, the birth of an American national character, engendered by the idea of the New World as a place of limitless opportunity and resources. The New World was a place where a man could reinvent himself—if he survived.

FIRST SETTLEMENT

When the English settlers landed at Jamestown Island in May of 1607, they were not alone in the New World. The English established their settlement within the territory of a thriving Native American civilization, the Powhatan Confederation. This was a loose association of thirty-plus Algonquian-speaking tribes living in the Coastal Plain. Archaeologists suggest that these tribes numbered approximately fifteen thousand people altogether. This association had been established by a ruler named Wahunsonacock, who is known to us as Chief Powhatan, the paramount chief of the Confederation. Though Powhatan was the powerful ruler of eastern Virginia as far west as the fall line[1] at the time the English landed, he is most remembered as the father of Pocahontas. While there were

other Indian tribes living in Virginia at that time, it was with the Powhatan that the English interacted most closely.

Although the Jamestown colony established in 1607 was the first successful Virginia colony, it was not the first attempt at colonization in Virginia. In 1570, the Spanish tried to establish a Jesuit mission in the Tidewater area; that mission ended in 1572, when all the priests were killed by the local tribes. In 1585, Sir Richard Grenville led a group of colonists in a first attempt to set up a colony on Roanoke Island (which is now in North Carolina). This colony was unsuccessful, and the colonists returned to England the next year. In 1587, Sir Walter Raleigh sent another group of colonists to Roanoke Island, this time under the direction of Governor John White. This attempt was also a failure; having returned to England for supplies, White returned to find the site of the settlement deserted, with no indication of what happened to the colonists.

No further colonization attempts were made by the English until December 20, 1606, when Captain Christopher Newport, in the employ of the Virginia Company of London, set out from England with 108 colonists, about 40 seamen and the instructions that "when it shall please God to send you on the coast of Virginia, you shall do your best [to] endeavour to find out a safe port in the entrance of some navigable river, making choice of such a one as runneth farthest into the land." (Additional secret instructions were only to be opened upon reaching the New World.)

On April 26, 1607, the ships the *Susan Constant*, the *Discovery* and the *Godspeed* entered the Chesapeake Bay and "there wee landed and discovered a little way, but wee could find nothing worth the speaking of, but faire meddowes and goodly tall Trees, with such Fresh-waters running through the woods, as I was almost ravished at the first sight thereof."[2] They stayed there four days, named the place Cape Henry and began to build a shallop (a shallow boat) in which Newport and his party would explore the James River over the next couple of weeks. One of those explorations was to the northern shore of Hampton Roads. "Wee rowed over to a point of Land, where wee found a channell, and sounded six, eight, ten, or twelve fathom: which put us in good comfort. Therefore wee named that point of Land, Cape Comfort."[3] On April 30, the convoy of three ships moved over to Cape Comfort, where they had their first close contact with the Indians, a small tribe called the Kecoughtan. In the following days, they were invited to visit several other tribes nearby, including the Paspahege and the "Rapahanna." Throughout this time, the colonists continued to search for a likely spot to establish their colony.

Two weeks later, on May 14, the colonists landed all their men (they were all men and boys) in the territory of the Paspahege and began work on a triangular, palisaded fort on a small, swampy island farther up the James River, which they called "James Citie" in honor

of King James I. By January 1, 1608, John Smith records that only thirty-eight of the original settlers survived, having succumbed to disease, accidents and attacks by the Powhatan. On January 2, Captain Newport returned to Virginia with the "first supply," another group of about seventy settlers and goods from England. The "second supply," in September 1608, brought more supplies and another seventy colonists, including the first two women to be part of the group.

Difficult Years

The first few years of the colony were rocky, at best. The English had arrived in Virginia at the beginning of a seven-year drought and in the middle of a period of excessively cold winters. Jamestown Island had no freshwater springs, and the rivers and well water became brackish as salt water infiltrated these sources. The site was not a particularly good hunting ground compared to other sites along the river. Above all, Jamestown was a company town. Its purpose was to make a profit for the shareholders of the Virginia Company of London; therefore, the company encouraged the colonists to look for sources of raw materials that could be shipped back to England, such as valuable metals and minerals, rather than plant crops and set up a permanent settlement.

Though the colony was dependent upon the Native Americans for food, the English maintained a patronizing attitude toward the Indians, treating them like children who needed to be instructed in English ways, when it was really the English who needed to learn from the Indians how to survive in the New World. Each group misinterpreted the other's actions and statements, viewing and hearing them through very different cultural filters. This continuing blindness to basic cultural differences very quickly caused hostility in both camps, which soon broke out into fighting. Atrocities were committed by both sides, and the fighting never really stopped until the tribes of the Coastal Plain were totally subjugated by 1677.

In addition, the colony suffered from poor leadership. The original military leader of the colony, Bartholomew Gosnold, died within months of the landing in August 1607. Edward-Maria Wingfield, one of the original owners of the Virginia Company, was the first president of the council. The other colonists were unhappy with the way he ran the colony, and he was deposed and jailed in September 1607, being accused of favoritism in the allocation of food. John Martin accused him of "doing slack in the service of the colony, and do nothing but tend his pot, spit and oven, [saying] 'But he hath starved my son and denied him a spoonful of beer. I have friends in England [that] shall be revenged on him if he ever come to London.'"[4] Wingfield was succeeded as president by John Ratcliffe, and a year later by Captain John Smith. Smith was not a popular president, as he

took some pains to persuade the men to plant Indian corn, but they looked upon all labour as a curse. They chose rather to depend upon the musty provisions that were sent from England: and when they failed they were forced to take more pains to seek for wild fruits in the woods, than they would have taken in tilling the ground. Besides, this exposed them to be knocked on the head by the Indians, and gave them fluxes into the bargain, which thinned the plantation very much. To supply this mortality, they were reinforced the year following with a greater number of people, amongst which were fewer gentlemen and more labourers, who, however, took care not to kill themselves with work.[5]

In 1609, the "third supply" brought two to three hundred new colonists to join the Jamestown community. It is this voyage that inspired Shakespeare's play *The Tempest*, because two of the nine ships in the convoy were wrecked off Bermuda in a violent storm. John Smith, not reelected to the office of president in the fall of 1609, was wounded in an accidental gunpowder explosion and left Virginia in October 1609 to recuperate in England. He never returned to the colony. He was succeeded as president by John Ratcliffe again, who died later in 1609 at the hands of the Powhatan while on a mission to request desperately needed food supplies for the colony.

The "starving time" winter of 1609–10 reduced Jamestown's population from some five hundred people to sixty. A new lieutenant-governor, Sir Thomas Gates, arrived on May 23, 1610, and seeing the desperate state of the colony, declared martial law the next day. Within two weeks, Gates had determined that the colony was not viable and decided to abandon the endeavor. The surviving colonists (including the group that had just arrived with Gates) packed up whatever provisions were left, buried their armor and weapons to prevent them from being found by the Indians and boarded Gates's ships to return to England. Fifteen miles downriver, they met a rowboat sent ahead from the ships led by Lord De La Warr, informing them that De La Warr's expedition carried food and other goods for the colony. With these reinforcements, Gates and the colonists returned to Jamestown to continue the colony.

Beginnings

The Powhatan's initial attitude toward the English was that the newcomers were visitors who were both potentially useful—because the trade goods the English had to offer were items that the natives valued, such as glass beads and copper—and potentially dangerous, because of their firearms. Powhatan may have intended to use the colonists as a way to escape the monopoly on copper held by the tribes of central Virginia. After 1609, when the English began establishing settlements in outlying areas in fertile farming land belonging to

the villages, the reaction of the chiefs was hostile, and the English responded in kind.

In 1612, John Rolfe, whose arrival had been delayed by way of the West Indies because of the tempest of the third supply, introduced tobacco as a commercial crop for the new colony. In 1613, Rolfe exported the first sample tobacco leaves to England, and this plant became the economic foundation of the colony, in spite of King James declaring it a "filthy novelty" in his *A Counterblast to Tobacco* (1604). Tobacco requires a great deal of land in its cultivation, since it exhausts the soil quickly, and new fields must constantly be cleared, but the early settlers lacked manpower for this job.

In 1616, the Virginia Company established the "headright" system of distributing land, promising fifty acres of land to anyone who would pay the fare to Virginia, and another fifty acres for each person who accompanied him. Men of means began to sponsor indentured servants to come to the New World. These immigrants would work for their sponsor for five to seven years by contract, and when the contract ran out, they were expected to buy their own land farther west, leaving the land obtained by headright the property of the sponsor.

As a result of this incentive, many settlements, called "hundreds" because they occupied tracts of land that would sustain one hundred households, were established up and down the James River. One such settlement was Martin's Hundred, which was established at the site that a century later was owned by Robert "King" Carter and is now called Carter's Grove.[6] This typical settlement was composed of a palisade and outlying houses and farms. The theory was that when notified of danger, the settlers would leave their houses and congregate in the palisade for protection.

In July 1619, the Virginia Grand Assembly met for the first time at the Jamestown church. This body was the first representative legislative assembly in British America, and by 1642 had evolved into the House of Burgesses. In 1624, the Virginia Company of London lost its charter because of mismanagement, and Virginia became a royal colony, with a governor, lieutenant governor and council appointed by the Crown. These positions usually went to members of the landed and moneyed gentry, thus transferring practical power to the planters. The Council of State had the duty of assisting the governor in the day-to-day activities of governing the colony. The president and secretary of the Council of State were very powerful and influential men, who, since they were appointed to the council by the king, often stayed in power for years.

The general assembly was composed of the members of the Council of State and "of two Burgesses out of every Town, Hundred, or other particular Plantation," and was to be called "once yearly, and no oftener, but for very extraordinary and important occasions." The governor or lieutenant governor had the power to dissolve or close a meeting of the general assembly. However, no law that was passed by the colonial government was legally enacted until formally approved

by the Crown, a requirement that caused considerable delays in implementation.

The first documented people of African origin arrived in Virginia in August 1619 aboard the *White Lion* and the *Treasurer*, English ships operating as privateers on a Dutch letter of marque. These Africans were originally sold by other Africans to Portuguese slave traders. "Their homelands were the kingdoms of Ndongo and Kongo, regions of modern-day Angola and coastal regions of Congo, [and they] spoke Bantu languages called Kimbundu and Kikongo."[7] Sailing from Luanda, Angola, and bound for Veracruz, Mexico, on the Portuguese ship the *San Juan Bautista*, these Angolans were confiscated by the *White Lion* and the *Treasurer* and taken to Jamestown, where they were exchanged for food. Some Africans in this group were treated as indentured servants, others as slaves.

POWER STRUGGLES

As Chief Powhatan grew older (he died in 1618), his brother, Opechancanough, chief of the Pamunkey, became the power behind the throne. In 1622, Opechancanough became the *werowance*[8] of the Powhatan Confederation in his own right. Opechancanough was, throughout his life, considerably more hostile to the English than Powhatan, and was the driving force behind the Indian conflicts with the colonists until his death in 1646.

The Powhatan used the period from 1613 to 1622 to become, on the surface, the friends of the English. In the background, they were quietly preparing a mass attack on the settlements. Their plan worked well, since when the attack finally came, it was almost a total surprise to the English. On March 22, 1622, the Powhatan conducted a massive, coordinated attack on the English settlements on the James River.

When the day appointed for the massacre had arrived, a number of the savages visited many of our people in their dwellings, and while partaking with them of their meal the savages, at a given signal, drew their weapons and fell upon us murdering and killing everybody they could reach sparing neither women nor children, as well inside as outside the dwellings. In this attack 347 of the English of both sexes and all ages were killed.[9]

The only town that escaped severe casualties in this massacre was Jamestown itself, and it survived only because an Indian servant named Chanco had notified his employer about the attack the night before. About one-quarter of the English people living in Virginia at the time were killed on that day. Another quarter died sometime during the year from the multiple minor raids the Indians conducted; from famine because they couldn't cultivate the fields under Indian fire; and from diseases caused by too many people living in Jamestown for protection from Indian attack.

After defeating the Powhatan in a battle in 1624, and finally making "peace" with the natives in 1632, the English continued to expand their settlements, spreading up the James River to the falls, down the Eastern Shore and up the Rappahannock and Potomac Rivers. The English felt betrayed by this uprising, having originally considered the Indians as innocent savages to be instructed in the civilized English way of life, and at this point stopped trying to include the natives in English society. After the attacks, the English considered the natives to be sub-human and sought to eradicate or enslave them.

Until 1644, the Powhatan continued to resist, unsuccessfully, the incursions of the English upon their lands. In that year, the Powhatan leadership unanimously came to the conclusion that something had to be done to keep the English from taking all their land. On April 18, 1644, the tribes again made a mass attack on the English settlements. About the same number of English died as in the 1622 attacks, but by then that number was only one-twelfth of the total number of English people living in Virginia.

The war ended with the capture of Opechancanough, who was by that time nearly one hundred years old. Then-Governor Sir William Berkeley intended to ship Opechancanough back to England as a royal captive, but the old chief died before that could happen when an English guard shot the old man in the back, later falsely claiming that he had tried to escape. A peace treaty was made in October 1646. The Powhatan became the subjects of the English and were required to pay an annual tribute. In spite of the natives being allocated the land on the York River's north bank, the English immediately resumed their expansion into these areas.

The Mattaponi and Pamunkey were allocated separate reservations in 1658, and remnants of those lands are still in the hands of the tribes today. By 1669, about 3,000 Indians remained, compared to the 15,000 originally residing in the Coastal Plain in 1607. The final treaty between the English and the native tribes was concluded in 1677 and signed by eight chiefs, including the "queen of the Pamunkey," Powhatan's niece, Cockacoeske.

Throughout the early history of Jamestown, status was fluid and depended less on one's economic and social status than on one's ability to survive. The immigrants of the period before 1640 were often indentured, preferring to come to the New World as servants rather than starve in the Old World, and there seemed to be no stigma attached to that status. Even the Africans who arrived in the early years were not automatically enslaved, but often indentured. However, in 1661, slavery was institutionalized in the new colony, with a law stating that the status of the mother should determine the free or slave status of the child.

As the government and laws of the colony became more established, a division occurred between the "planters"—those with land—and the artisans and laborers. The first law passed in 1624 by the general

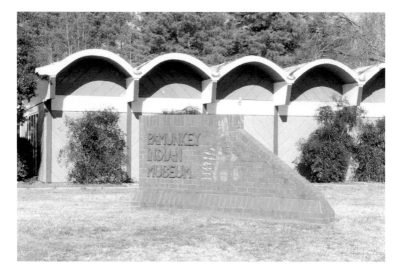

Pamunkey Museum, Pamunkey Reservation, King William, Virginia, 2006. *Author's collection.*

assembly was to set the price of tobacco. This division came to a head in 1676 with Nathaniel Bacon's rebellion, an event that was for many years viewed as the first action demonstrating the independent American spirit. More recent historical analysis shows that the conflict was between Governor Berkeley and Bacon, who wanted more power in the government than Berkeley was willing to give him. In retaliation, Bacon used the disgruntlement of the other classes at the favoritism of the colonial government and its apparent inaction concerning their troubles with the Indians to foment a rebellion that ended that summer only after Jamestown burned to the ground and Bacon himself died of dysentery.

Jamestown was rebuilt after the tumultuous summer of 1676, this time in brick rather than wood. It continued to be the center of the Virginia government until 1698, when the fourth state house burned down. The next year, the capital was moved to the Middle Plantation, later named Williamsburg, and Jamestown was largely abandoned. By 1807, Jamestown Island was divided between the plantations of the Ambler and the Travis families, and only the old church tower remained to indicate that this was once the site of the prosperous James Citie.

READ MORE ABOUT IT

Kelso, William. *Jamestown, the Buried Truth.* Charlottesville: University of Virginia Press, 2006.

Noel Hume, Ivor. *Martin's Hundred.* Rev. ed. Charlottesville: University of Virginia Press, 1991.

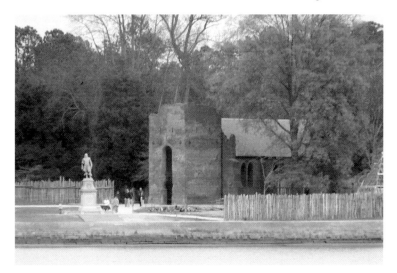

The recreated palisade at Jamestown, and the ruins of the later church and tower, 2006. *Author's collection.*

————. *The Virginia Adventure: Roanoke to James Towne: An Archaeological and Historical Odyssey.* Charlottesville: University of Virginia Press, 1997.

Price, David. *Love and Hate in Jamestown: John Smith, Pocahontas, and the Heart of a New Nation.* New York: Alfred A. Knopf, 2003.

Rountree, Helen C. *Pocahontas, Powhatan, Opechancanough: Three Indian Lives Changed by Jamestown.* Charlottesville: University of Virginia Press, 2005.

Thornton, John. *Africa and Africans in the Making of the Atlantic World, 1400–1800.* 2nd ed. Cambridge: Cambridge University Press, 1998.

WEBSITES

Henricus Historical Park (http://www.henricus.org/). This park recreates the original 1611 city of Henricus and Arrohateck, a seventeenth-century Virginia Indian encampment.

Virtual Jamestown (http://www.virtualjamestown.org/). An interactive website containing transcripts of public records, publications, newspapers and correspondence, as well as maps, illustrations and other information pertaining to Jamestown.

Chapter 2

The Settling of Central Virginia
(1700–1775)

The Powhatan were not the only natives of Virginia in 1607.
Another group of Native Americans—the Monacan and their
allies, the Mannahoac—resided in the Virginia Piedmont, between
the fall line and the mountains. The Monacan had several villages
located up and down the Piedmont near the James River, with their
main village, Rassawek, located at Point of Fork, where the Rivanna
River meets the James River. The Mannahoac had established several
towns to the north on the Rappahannock River.

Because the English settlers had little contact with the Monacan
villages—in fact, there are only three mentions of the Monacan and
the Mannahoac in the early records of Jamestown—until recently
historians have assumed that the Monacan Confederacy was a less
powerful group of tribes, and that the population of the Monacan
tribes was much smaller than that of the Powhatan. However, recent
archaeological research indicates that the population of the Central
Virginia tribes could have been between twelve and fifteen thousand,
or roughly equal to the population of the Powhatan Confederacy.[10]
(The burial mounds built by the central Virginia Indians contain
the largest number of individuals found in any mounds previously
excavated in the United States, so these population estimates are
probably conservative.)

Almost immediately after the landing at Jamestown, Captain
Christopher Newport took a group of twenty-three colonists on
an exploratory foray up the James River. On May 24, 1607, the
expedition camped near the fall line of the James River and was hosted
by Pawatah, a local *werowance*. (Pawatah was a son of Powhatan, but
at that time the English thought that he was the paramount chief
himself.) After dinner, the talk turned to the James River and how
far it was to the Blue Ridge Mountains. During this conversation, the
English were informed that it was a day-and-a-half journey to the
land of the Monacan. Gabriel Archer, a member of the group, said in
a letter that Pawatah "told us that the Monanacah was his enemy, and

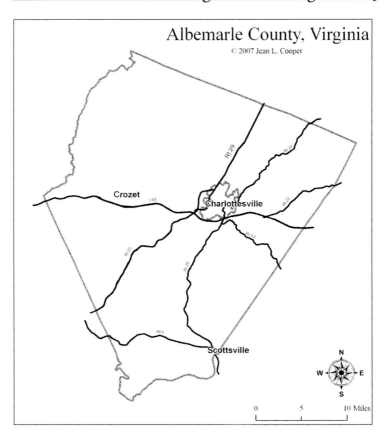

Map of Albemarle County, with major highways and roads, 2007. *Author's collection.*

that he [the Monacan] came down at the fall of the leaf and invaded his country."[11]

Though the Powhatan and Monacan spoke different languages, they engaged in regular trade, as well as seasonal war-making. In Archer's letter mentioned above, he relates that one of the Indians secretly revealed that the Monacan were the source of the blue metal (copper) that was so valued by the Indians. So valued was copper that only the chiefs and priests wore copper ornaments.

In 1608, Captain John Smith led an expedition up the Rappahannock River, where the group was set upon by Mannahoac warriors (allies of the Monacan). Having captured Amoroleck, a warrior wounded in the attack, Smith questioned him through a Powhatan interpreter and "demanded why they [the Mannahoac] came in that manner to betray us, that came to them in peace, and to seeke their loves; he [Amoroleck] answered, they heard we were a people come from under the world, to take their world from them." When Amoroleck was questioned further about the Indians of the interior, Smith reports, "The Monacans he

sayd were their neighbours and friends, and did dwell as they in the hilly Countries by small rivers, living upon rootes and fruits, but chiefly by hunting."[12]

John Lederer, a German scholar authorized to explore the interior by colonial Governor William Berkeley, seems to have been the first European to write about his travels in the area of central Virginia.[13] During Lederer's first trip (he made three trips between March 1669 and August 1670), he followed the Pamunkey River upstream from "Pemaeoncock Falls, alias York-River in Virginia" to the Southwest Mountains, near modern-day Orange, Virginia.

Starting out on March 9, 1669, he records on March 14 that "from the top of an eminent hill, I first descried the Apalatean Mountains, bearing due West to the place I stood upon: their distance from me was so great, that I could hardly discern whether they were Mountains or Clouds."[14] Four days later, on March 18, Lederer climbed what modern historians believe to be the Southwest Mountains, which together with the Blue Ridge Mountains on the west bracket the valley in which Charlottesville lies. Compared with Captain John Smith, who thought that the Indian Ocean was only a short distance west of the Appalachian Mountains, Lederer believed that "they are certainly in great errour, who imagine that the Continent of North-America is but eight or ten days journey over from the Atlantick to the Indian Ocean."[15]

Lederer also seemed to be unusual in that he was interested in the natives of the region, and during his travels he visited several villages, ate the native foods and followed the directions of his native guides. He begins his narrative with a description of Indian life.

> *And the Indians now seated here, are distinguished into the several Nations of Mahoe, Nuntaneuck, aliàs Nuntaly, Nahyssan, Sapon, Managog, Mangoack, Akenatzy, and Monakin, & c. One Language is common to them all, though they differ in Dialects. The parts inhabited here are pleasant and fruitful, because cleared of Wood, and laid open to the Sun. The Valleys feed numerous herds of Deer and Elks larger then Oxen: these Valleys they call Savanae, being Marish [marshy] grounds at the foot of the Apalataei, and yearly laid under water in the beginning of Summer by flouds of melted Snow falling down from the Mountains.[16]*

The Monacan and their related tribes were Siouan speaking, as opposed to the Algonquian-speaking coastal villages, which indicates a common origin among the tribes of the Piedmont region.

> *The Indians now seated in these parts, are none of those which the English removed from Virginia [the Powhatan], but a people driven by an Enemy from the Northwest, and invited to sit down here by an Oracle above four hundred years since, as they pretend: for the ancient inhabitants of Virginia were far more rude and barbarous, feeding onely upon raw*

flesh and fish, until these taught them to plant Corn, and shewed them the use of it.[17]

Lederer was a bit off in his calculation of the length of time since the Monacan settled in the area, since archaeological evidence indicates that they have been in the Piedmont region for at least ten thousand years. Lederer's description of the Monacan as farmers is borne out by additional archaeological evidence. About 900 CE (Common Era), the Monacan began to plant maize (corn), squash and beans, and as a result, permanent villages grew up near the rivers.

The explorer also discussed the native methods of using mathematics and keeping track of time, saying,

> *Though they want those means of improving Humane Reason, which the use of Letters affords us; let us not therefore conclude them wholly destitute of Learning and Sciences: for by these little helps which they have found, many of them advance their natural understandings to great knowledge in Physick, Rhetorick, and Policie of Government: for I have been present at several of their Consultations and Debates, and to my admiration have heard some of their Seniors deliver themselves with as much Judgement and Eloquence as I should have expected from men of Civil education and Literature.*[18]

Unlike the Powhatan, who at first were relatively friendly to the English, and who later pretended to be friendly, the Monacan seemed to want little to do with the interlopers. As the English filtered westward, the Monacan also moved north, south and west to get away from them. An example of this was the Monacan village on the original site of the town of Manakin, just west of Richmond. In this case, the Indians withdrew from the town mere days or weeks before a group of Huguenot settlers came up the James and settled into the buildings and used the supplies left by their former occupants.

This deliberate retreat led many Europeans to believe that the Monacan civilization had declined and disappeared many years before the English arrived on the scene. Monasukapanough, situated on the south fork of the Rivanna River near Charlottesville, was one of the largest Monacan villages and was noted on Captain John Smith's 1612 map of Virginia. There is some reason to believe that Monasukapanough was largely abandoned about 1670, but still had inhabitants as late as the early 1700s, because it was clearly remembered and the location known into the 1750s.

In his *Notes on Virginia* (1781–82), Thomas Jefferson described

> *a party* [of Indians] *passing, about thirty years ago, through the part of the country* [at Monasukapanough] *where this barrow is, went through the woods directly to it, without any instructions or enquiry, and having staid about it some time, with expressions which were construed to be those*

of sorrow, then returned to the high road, which they had left about half a dozen miles to pay this visit, and pursued their journey.[19]

About 1780, Jefferson excavated this burial mound, a project that has been called the first scientific archaeological excavation in America, and he describes it in detail in his *Notes*. There have been several other excavations of the site since then, and the ground has been farmed and plowed, so that it is no longer possible to tell that hundreds of people once lived here.

WESTWARD EXPANSION

As they had been doing since 1607, the English colonists kept pushing westward in their desire for more land on which to grow tobacco. In 1705, Francis Makemie wrote that "the best, richest, and most healthy part of your Country is yet to be inhabited, above the Falls [the fall line] of every River, to the Mountains, where are sundry Advantages not yet generally known."[20] Land in the Coastal Plain had become scarce, and it was impossible to buy large tracts anymore, so those men who wished to better themselves had to go farther west to find land for planting and speculation.

In 1716, Lieutenant Governor Alexander Spotswood set out with sixty-two other men to explore the frontier, with the intent of discovering lands for westward expansion, and incidentally, securing trade with the Indians from the French. The party crested the Blue Ridge at Swift Run Gap,[21] near what is now the entrance to Shenandoah National Park, on U.S. Route 33. There, reported John Fontaine—one of the adventurers—they celebrated with several toasts to the king and to Spotswood. A monument and historical plaque mark their crossing there. The expedition descended into the Shenandoah Valley, stopping at the Shenandoah River near the current town of Elkton, where again they celebrated with toasts of wine, brandy and claret. However much this expedition was presented as a quest for adventure, it was also a public relations jaunt; Spotswood's actual intentions were to open up the frontier of Virginia to European settlement, and by 1750, the Piedmont and the Shenandoah Valley were mostly settled.

In 1727, Goochland County was created from Henrico County (one of the original eight Virginia counties). As the frontier was pushed farther west and the land was filled in by the swelling tide of European settlers seeking acreage, the counties were split and reallocated in order to make it easier for those who lived in each county to attend court sessions in a centrally located county seat. In 1744, Goochland was divided into several smaller counties, including Albemarle County, named after William Anne Keppel, the second earl of Albemarle, who was then the royal governor of Virginia.

ALBEMARLE COUNTY AND SCOTTSVILLE

The early system of headrights was at this time no longer used by the colonists, so Albemarle County was settled using the patent system of land grants. This system allowed an individual to pay a fee (usually a token amount) to the Crown for a "patent" on the land, which gave him temporary ownership. That landowner now had three years to "improve" the land, that is, to plant crops on three out of every fifty acres in the patent and to build a dwelling place on the property. If the improvements were not made in the time allotted, the land reverted back to the Crown, which resold the patents.

Between 1722 and 1726 three grants were made of Albemarle County land, but this acreage was never developed. In 1727, George Hoomes Jr. received 3,100 acres near the Southwest Mountains, and Nicholas Meriwether patented a grant of over 13,000 acres in the same region. In 1734 and 1735, surveyor Peter Jefferson came to the county while laying out the route for the Old Mountain Road from Richmond to the D.S. tree in what is now Ivy, Virginia. This road, based on a well-traveled Indian path, eventually joined with a road being built by Michael Woods, running from Woods' Gap in the Blue Ridge to Ivy. The resulting road came to be known as Three Notch'd or Three Chopt Road.[22] The route remained the same until the 1930s, when State Route 250 was built. Route 250 follows the path of Three Notch'd to Mechum's Creek, and then turns south to follow Dick Woods' Road and part of the Staunton and James River Turnpike to cross Rockfish Gap in the Blue Ridge. Although the new road straightened the route a bit, the roadbeds generally follow the same paths that they have for three hundred years.

By 1735, George Nicholas had established the first settlement within Albemarle's present boundaries near Warren. Also in that year, Abraham Lewis patented 800 acres, most of which are now the grounds of the University of Virginia, and Nicholas Meriwether patented an additional 1,020 acres, including the land that is now the eastern part of Charlottesville. Two years later, William Taylor patented 1,200 acres between the Lewis and Meriwether grants, acreage that was later owned by Richard Randolph. These three grants are the basis of today's Charlottesville. By the county's formation in 1744, much of the land within its boundaries had been patented. In 1745, there were 1,394 tithables (white males and blacks of both sexes, sixteen and above) in the county.

On February 28, 1744/1745,[23] Joshua Fry, Peter Jefferson, William Cabell, Alan Howard, Joseph Thompson and Thomas Bellew met at Mr. Scott's house at the Horseshoe Bend of the James River to establish the government of the new county. Edward Scott had patented five hundred acres in this area in 1732 and had built Valmont on a bluff above the river. His sons, Daniel and Samuel, who had inherited the property in 1738, offered the new justices a parcel of land on which

to build a courthouse "identical to the Goochland Court House," with a prison, stocks and pillory, on a hill about a mile west of present-day Scottsville, on the Valmont estate. Thus the first county seat of Albemarle came to be Scott's Landing (now called Scottsville).

In addition to being centrally located in the county, Scott's Landing had the advantage of being on the James River, the main thoroughfare for trade and transportation in colonial times. The Horseshoe Bend of the James had been a thoroughfare and river crossing for the Monacan for hundreds of years. It was much faster and cheaper to send crops to market in Williamsburg by river, since it took only days instead of an arduous three-week overland journey by wagon on rough roads. Scott's Landing was also sited at the location of a ford in the only break in the bluffs along the James for a distance of six miles, making it the easiest place to unload the barges that were delivering goods to be transported by wagon to their final destinations.

For the first four or five years of the county's existence, Court Days were held every month. These were occasions to accomplish the business of the court, but also for trading goods and visiting with one's neighbors, since everyone came to town on those days. Very soon after authorizing the building of a courthouse, the justices also authorized the building of a tavern (or ordinary).

CHARLOTTESVILLE

In 1761, as in 1744, the population in Albemarle County had increased so much that the county was again split into several smaller counties, including Buckingham and Amherst Counties.[24] This put Scott's Landing at the very southern edge of the county—not a central location easily accessible to all residents of the new county.

The county seat was moved by act of the general assembly to a more central location in 1762. A tract of one thousand acres was acquired from Colonel Richard Randolph, land that had been a part of the William Taylor patent of 1737. The town was named Charlottesville in honor of Sophia Charlotte of Mecklenburg-Strelitz, the new wife and queen of King George III. Dr. Thomas Walker of Castle Hill helped lay out the initial fifty-acre plan for Charlottesville and was made trustee for the sale of its lots. At one pound sterling per acre, fourteen town lots were sold in 1763 and ten in 1764.

Since the land had never been developed, the planned town was laid out in a grid pattern. There were four east-west streets (Jefferson, Market, Main and Water) and six north-south streets (Court, now Fifth; Union, now Fourth; School, now Third; Church, now Second; Green, now First; and Hill, now Second West). Each square contained two half-acre lots, fifty-six lots in all. Main Street was part of the Three Notch'd Road,[25] the main east-west route from Richmond to the Shenandoah Valley. Most of the early buildings were on Jefferson, Market and Main Streets.

The two-acre public square on the north side of Jefferson Street, the present-day Court Square, remained county land. The square contained a courthouse, a jail, a pillory, stocks and a whipping post. The first courthouse was a large wooden frame building that served as the public building of the town. The magistrates held court in this building, all county elections were held here and nearly all public assemblies took place here. Since Charlottesville had no church buildings until 1826, the courthouse was used for services, with the Catholics, the Baptists, the Episcopalians and the Methodists each taking one Sunday a month.

In 1773, John Jouett Sr. purchased the lot east of the courthouse and established the Swan Tavern. In 1790, the general assembly authorized the addition of twenty acres to the original fifty that composed the city. These twenty acres belonged to Jouett, and he was allowed to offer for sale lots of one-half acre each. This was the origin of Maiden Lane (now High Street) north of the courthouse.

Tour—Scottsville

Scottsville is located where State Route 20 crosses the James River. From Charlottesville, take Route 20 south. The first part of this road, from Charlottesville to Carter's Bridge, follows the route of the old Secretary's Mill Road that was built in the mid-1730s. From that point, the road is called the Scottsville Road, and at Keene it joins with the Staunton and James River Turnpike (built in sections from 1790 to 1840) that connected commerce in the Shenandoah Valley to the James River (see Chapter 4). Scottsville's Main Street is primarily residential and runs parallel to the James River, while the business district is on Valley Street, which runs perpendicular to the river through the central business district of the town. Scottsville was incorporated as a town in 1818.

Among the events that attract visitors to Scottsville is the James River Batteau Festival (http://www.batteaufestival.com/), held annually in late June. The festival is a 120-mile, eight-day batteaux trip down the river from Lynchburg to Richmond.

The Scottsville Historic District (NRHP, VLR) contains 153 buildings that are examples of many different styles of architecture, ranging from the Colonial style of the eighteenth century through the Craftsman style of the early twentieth century. Many of the buildings are privately owned homes and are not open to the public unless otherwise indicated. This tour is set up in three sections: a walking tour of the central town, a driving tour of areas farther away and an optional side trip following the River Road west of town.

Main Street and Canal Basin Square (except for the levee) are on one level and easily walkable. The same is true of Valley Street, which follows a ravine to the James River. Jackson Street is short and paved, but those using walkers or motorized carts may have some difficulty

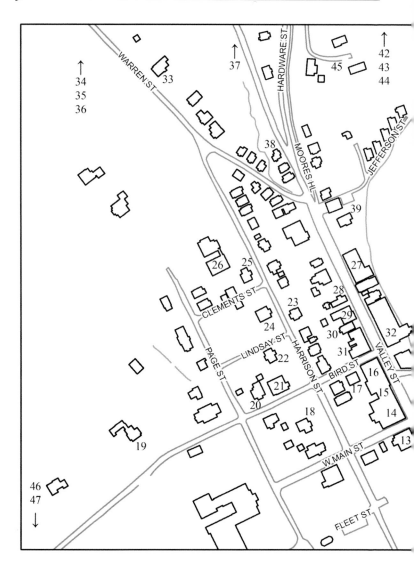

Map of Scottsville historic district tour, 2007. *Author's collection.*

negotiating the steep incline. West of Valley Street, the terrain inclines steeply up the hill, away from the river, and may likewise be difficult to negotiate on foot for those with mobility issues.

WALKING TOUR

1. SCOTTSVILLE MUSEUM (300 MAIN STREET)
http://avenue.org/smuseum/
Begin your tour at the Scottsville Museum. This building was originally a Disciples of Christ Church and was built around 1846, next to the

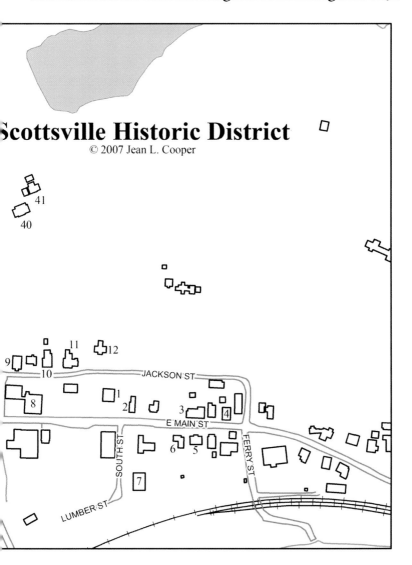

Scottsville Historic District
© 2007 Jean L. Cooper

home of its first pastor, Dr. James Turner Barclay. Barclay embraced the views of the Disciples of Christ reform movement of the 1840s, and established the third church of that denomination in Virginia at Scottsville. Barclay himself made the original benches and altar pieces that are displayed in the museum. Church services were held in the building for about one hundred years. The museum opened in 1970.

2. BARCLAY HOUSE (302 MAIN STREET)
The next house to the east was the home of Dr. Barclay, mentioned above. Barclay House is a Georgian-style brick townhouse, originally built on Scottsville lot 31 between 1830 and 1838. The house was purchased in 1838 by Sarah C. Harris, Dr. Barclay's mother. The main

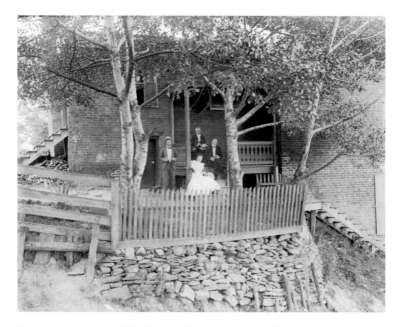

Barclay House, circa 1900. *Burgess Collection, Scottsville Museum, Scottsville, Virginia.*

floor of the house has almost always been used as a store, although it was a broom factory in the early 1900s. The top floor was the home of the Barclay family from 1838 to 1851. The brick front steps are a modern addition. The family used the side entrance on the top floor as their front door. This building is part of the Scottsville Museum complex and is open to the public on the same schedule.

Barclay was an interesting person; in addition to being a preacher and a missionary, he was also a practicing doctor and pharmacist. After the death of Thomas Jefferson, Barclay purchased Monticello, and in 1836 he sold the Monticello estate to Uriah P. Levy, a commodore in the U.S. Navy. The Levy family maintained the house until it was purchased in 1923 by the Thomas Jefferson Foundation and opened to the public.

In 1851, Dr. Barclay went to Jerusalem as the first missionary sponsored by the American Christian Missionary Society, and sold the Barclay House to a Mr. Staples, an elder in the Disciples of Christ Church. In 1854, between missions to the Holy Land, Barclay worked at the Philadelphia Mint, having been commissioned to find ways to stop the counterfeiting of currency. Returning from Jerusalem for good in 1865, Barclay became the chair of Natural Sciences at Bethany College in Bethany, Virginia (now West Virginia).

3. The Old Tavern (360 Main Street)
The second building to the east is the Old Tavern, built about 1840. It was apparently built in two stages—the western one-story portion

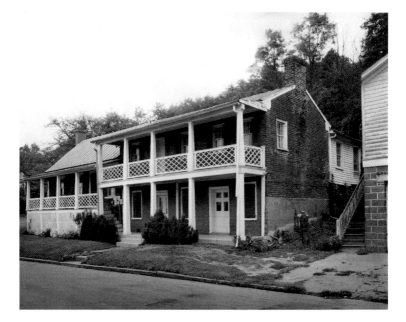

The Old Tavern, 1969. *Burgess Collection, Scottsville Museum, Scottsville, Virginia.*

(nearest downtown) first, and the eastern two-story portion last. The style is typical Federal or Early Republic. This building was originally used as a tavern and hotel.

4. THE DOLL HOUSE (386 MAIN STREET)

The second house to the east of the Old Tavern is the Doll House. This is a frame house that was built around 1810. It was once owned by Peter Field Jefferson, the grandson of Thomas Jefferson's brother, Randolph. The Reverend A.J. Doll, who co-founded the Union Baptist Church on Hardware Street, was a later owner, and it is he for whom the house is named. This brick building has a gabled roof and is one and a half stories, with a stone basement and a one-story porch across the front.

5. HERNDON HOUSE (361 MAIN STREET)

Across the street from the Old Tavern is Herndon House. This is a frame house built between 1790 and 1810. It is a "double house," with a chimney on either end and a central hall that goes from

The Doll House, Scottsville, Virginia, circa 1920s. *Raymon Thacker Collection, Scottsville Museum, Scottsville, Virginia.*

front to back, dividing the house into two sections and allowing for cooling ventilation.

6. THE COLONIAL COTTAGE (345 EAST MAIN STREET; ALSO CALLED THE FORE HOUSE)

The next house to the west is possibly the oldest remaining building in Scottsville. The back wing is thought to have been constructed about 1732; the front part of the house was built around 1780. The roof, steeply pitched and side-gabled, is covered in standing-seam metal. The entire house is clad in the original beaded weatherboarding with rose-headed nails. (NRHP, VLR)

7. KANAWHA CANAL WAREHOUSE (225 SOUTH STREET; ALSO CALLED THE FARMER'S EXCHANGE)

Continuing west on Main Street, you will come to a large park called Canal Basin Square, sited where the turning basin used to be. The square is a historical park, containing a replica packet boat and a demonstration model lock. It was dedicated on September 20, 2003, and celebrates the James River and Kanawha Canal, which helped make Scottsville a thriving center of commerce until the 1860s.

Scottsville has suffered a number of severe floods in the past hundred years, the worst being the great flood of 1870 (thirty feet) and Hurricanes Camille in 1969 (thirty feet) and Agnes in 1972 (thirty-four feet). In 1990, the levee between the square and the James was dedicated, and Scottsville has not flooded since that time. If you climb to the top of the levee and follow the walking path, you will be able to see the James River and the railroad track that was laid in the late nineteenth century on the canal boat towpath.

The large building on the southeast corner of the square is the Kanawha Canal Warehouse, which sits on the canal bank facing the site of the turning basin used by the canal boats. The boats would load and unload on this side of the building, while on the other side of the building, goods were loaded and unloaded to and from wagons traveling the Valley Road to Staunton. The canal and its turning basin are now filled in, and the towpath is the bed of the railroad track. The canal was fifty feet wide and stretched from Richmond to Lynchburg alongside the James River.

The warehouse is believed to have been built by Peter Field Jefferson about 1830, although one theory is that the building was finished in 1844, based on circular saw marks on the main support beams. No other example of antebellum commercial architecture of this kind still exists on the James River. It is made with massive heart-pine beams and local brick laid in the American bond pattern. The building was partly destroyed by Sheridan's army in 1865, and the gambrel-style slate roof is believed to be part of the renovation after this attempted destruction. It has four large bays and three stories, with a partial attic

Kanawha Canal Warehouse, Scottsville, Virginia, 2006. *Author's collection.*

space as a fourth story and a basement. In 1944, the building was purchased by the Scottsville Fire Department and served as a venue for dances sponsored by the Scottsville Fire Department and the Lions' Club.

8. Scottsville Methodist Church (158 Main Street)
On the north side of Main Street across from Canal Basin Square stands the Scottsville Methodist Church, built in 1833. This was

Scottsville Methodist Church, 1920. *Burgess Collection, Scottsville Museum, Scottsville, Virginia.*

Tompkins House, 1969. *Burgess Collection, Scottsville Museum, Scottsville, Virginia.*

originally a single rectangular building with an entrance on the front and a steeple. The side additions were made when the building was renovated in 1930. In 1976, the building suffered severe damage in a fire, but was restored to its present form.

9. TOMPKINS HOUSE (180 JACKSON STREET)
Cross to the west side of the Methodist church and follow Church Street north to Jackson Street. The first house you see on the north side of Jackson is the Sally Tompkins House. This is a one-story Greek Revival brick house with a high basement. It was built around 1835 by Dr. Samuel W. Tompkins. The town well and water pump used to be in front of this house. (NRHP, VLR)

10. THE TERRACE (210 JACKSON STREET)
Continuing east on Jackson Street, the second house is the Terrace, a two-story Queen Anne–style house built in 1897 by Dr. and Mrs. David Pinckney Powers.

11. THOMAS STAPLES HOUSE (240 JACKSON STREET)
The next house to the east is the Thomas Staples House, a frame house built about 1840. Most of the house has the original beaded weatherboarding. The house was originally built with four chimneys, two on each end of the house, but the addition on the east has enclosed those chimneys so that only the tops are visible.

The Terrace, 1897. *Burgess Collection, Scottsville Museum, Scottsville, Virginia.*

12. OLD METHODIST PARSONAGE (270 JACKSON STREET)

Continuing east, the next house was for a long time the parsonage for the nearby Scottsville Methodist Church. It was built about 1836, and purchased by the church in 1885.

13. DORRIER BUILDING (280 VALLEY STREET)

Follow Jackson Street west and cross Valley Street. The building on the southwest corner of Main and Valley Streets is the Dorrier Building, which was built in 1912 by William Dorrier and served as a general merchandise and feed-grain store. It is now a grocery store and deli. Many of these commercial buildings on the west side of Valley Street were originally built in the Federal style in the 1840s, and except for enlarged display windows, the façades look much the same as they did in the nineteenth century.

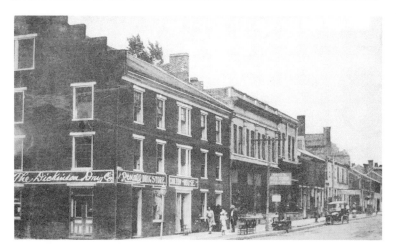

West side of the 300 block of Valley Street, Scottsville, Virginia, circa 1915.
The Carlton House Hotel is in the foreground, with the Wyman and Griffin
Buildings and the Beal Building receding into the distance. *Collection of J. Tracy
Walker III, Charlottesville, Virginia.*

14. CARLTON HOUSE (300–310–320 VALLEY STREET; ALSO CALLED THE BRUCE BUILDING)

Go north on Valley Street. On the northwest corner of Main and
Valley Streets is the Carlton House, built about 1832. It was one of
the many hotels and taverns in Scottsville that fulfilled the needs of
passengers and crews who passed through this busy port. This building
also served as part of the Scottsville General Hospital during the Civil
War. The building was purchased by Thomas Ellison Bruce, the town's
pharmacist, in 1927, and remodeled in 1928. Bruce later served four
terms as Scottsville's mayor, from 1935 to 1943, and two terms as
Albemarle County supervisor. Bruce's Drug Store remained in this
building until 2003.

15. WYMAN AND GRIFFIN BUILDINGS (348 AND 358 VALLEY STREET; ALSO CALLED THE OLD POST OFFICE)

Continue north on the west side of Valley Street, and you will come
to a row of Federal-style commercial buildings. The Wyman (south)
and Griffin (north) Buildings are identical and look as if they are one
building. They were constructed about 1830. The Wyman Building
was the town post office from 1884 to 1914.

16. BEAL BUILDING (380–398 VALLEY STREET)

This building on the southwest corner of Valley and Bird Streets
was built by the Beal family about 1840. Mayor Jackson Beal Sr. had
his office here. The town court was held on the second floor of this
building for many years, and U.S. Senator Thomas Staples Martin,
elected in 1895, had his office here for twenty-five years.

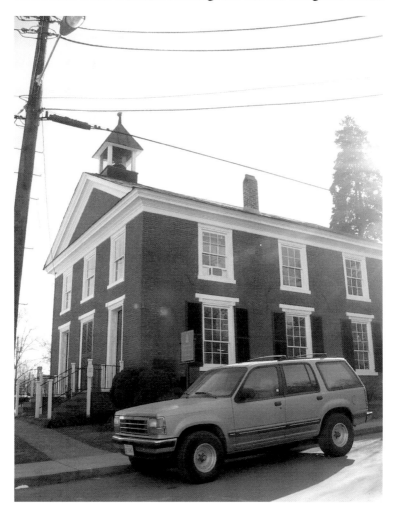

Scottsville Presbyterian Church, 2006. *Author's collection*.

17. SCOTTSVILLE PRESBYTERIAN CHURCH (145 BIRD STREET)
Turn west onto Bird Street. On the south side of the street in the center of the block is the Scottsville Presbyterian Church. It is the oldest church in town. The congregation was organized in 1827, and the church itself was built in 1832 on land belonging to Peyton Harrison. Harrison influenced the congregation to move from Warren to Scottsville in 1830, and helped finance construction of the new church. It is a two-story Greek Revival–style building, representative of church architecture in Virginia in the early nineteenth century. Church history states that at one time there was an exterior wooden staircase leading to the second-floor gallery used by slaves.

Grove House, the Colonial Revival house just west of the church, was built in 1932 on land that had been the site of the old Presbyterian

Church Cemetery. It was owned by Jesse and Jacqueline Beal Grove until the latter's death in 2001. Mrs. Grove was the last of the Beal family to live in Scottsville.

18. OLD HALL (354 HARRISON STREET)

Continue west on Bird Street and turn left onto Harrison Street. Halfway down on the west side of the street is Old Hall, built in 1830 by an architect named Magruder[26] for James W. Mason, president of the Bank of Scottsville. Mason moved to Hatton Grange in 1850. The home was purchased in 1856 by Joseph Russell Beal, who added the nursery. The Beals were a mercantile family who moved to Scottsville from Richmond, and prospered until the Civil War. Old Hall was in the Beal family for 101 years, until 1957. The house has elements of both the "old" Federal style and the "new" Greek Revival style. The house is two stories with an English basement. The most unusual features of the house are the tripartite windows on the first and second stories in the front and the first story in the rear, of which there are few examples in Virginia.

On March 9, 1865, during the occupation of Scottsville by Sheridan's army, Old Hall was the headquarters of Union General Wesley Merritt. According to Virginia Moore's book *Scottsville on the James*, Merritt ordered the Beal family to the basement. "'Old lady,' said General Merritt to the mistress of Old Hall, 'we've come to starve you to death.' Mrs. Mary Elizabeth Beal answered with spirit, 'Then you'll have to pull up every sprig of cress salad in Gantt's low grounds. It's spring.'"[27]

The house was used as the First Sanatorium of Southside Albemarle Hospital from 1882 to 1883, when the Beal family rented the house to Drs. John S. and Oriana Moon Andrews.

19. BREEZEWOOD (380 BIRD STREET, THE ZACK JONES HOUSE)

Returning to Bird Street, turn west and cross Page Street. Breezewood is located next to the Scottsville Public Library. Zachariah Fleming Jones was a member of Mosby's Raiders (Company D, Forty-third Battalion Virginia Cavalry) during the Civil War. After the war, he returned to Scottsville, where he lived for the rest of his life. In 1897, Jones purchased this wood-frame late Victorian house and three-acre lot.

20. CLIFFVIEW (280 BIRD STREET)

On the north side of Bird Street, between Page and Harrison Streets, is this two-story Colonial Revival house, built in 1914.

21. ST. JOHN'S EPISCOPAL CHURCH (410 HARRISON STREET)

Turn left onto Harrison Street and go north. The building on your left is St. John's Episcopal Church. In the eighteenth century, Albemarle County was divided into two Episcopal parishes. St. Anne's was the

Old Hall, 1973. *Photo by Ed Roseberry; Burgess Collection, Scottsville Museum, Scottsville, Virginia.*

southern parish, and Frederick's Parish the northern. The boundary was the Three Notch'd Road. The original parish church of St. Anne's Parish was built at the Glebe, north of Scottsville, and as time passed, several additional Episcopal churches were established in Albemarle County. By the 1870s, there were enough parishioners in Scottsville to form their own church. This is a wood-frame, Gothic Revival–style building with a steeple and peaked windows. It was built in 1875 and is the only building of this style in Scottsville. The adjoining parish house was built in 1949. This building has been in continuous use as a church for over one hundred years.

22. THE SHADOWS (470 HARRISON STREET)
Continuing north, the next house on your left is the Shadows, believed to have been built around 1830 by a member of the Scott family, although an older inner log wall was recently discovered that indicates a portion of the house is of earlier construction. It is possible that the house was built on an older foundation, or enlarged from an earlier log cabin. The two-story, Greek Revival frame house has a brick basement, a gabled slate roof, pit-sawn timbers, beaded weatherboarding and an octagonal addition. Also on the property are the original slave quarters, a smoke house and a summer kitchen.

This property was part of the original Scott plantation, later owned by Peyton Harrison, a grand-nephew of Declaration of Independence signer Benjamin Harrison. Peyton Harrison donated the five-hundred-

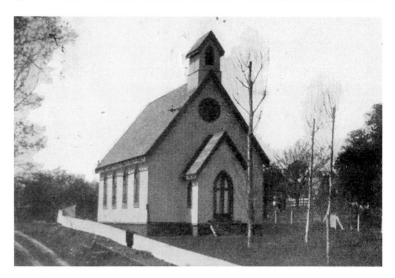

St. John's Episcopal Church, Scottsville, Virginia, circa 1911. *Photo by W.E. Burgess; Collection of J. Tracy Walker III, Charlottesville, Virginia.*

acre "Harrison Addition" to the town of Scottsville in the early nineteenth century, an area comprising most of the properties west of Harrison Street.

23. Dr. Reuben Lindsay's House (521 Harrison Street)

Look to the east side of Harrison Street and slightly south, and you will see a small, one-story Greek Revival house of brick, with a paired-column portico. Originally the house was a double cottage, and it still has two front doors. There is a two-story frame addition at the rear of the structure. There is some dispute on the age of this building; some sources say it was built about 1800, although 1850 seems more likely. In any case, it was for many years the home of Dr. Reuben Lindsay, who had started his practice in Scottsville by 1831 and died in 1881. Dr. Lindsay was the nephew of Colonel Reuben Lindsay of Springfield Farm in northern Albemarle County, who commanded the Albemarle militia during the Revolution. The doctor was deeply mourned by all in the area upon his death. His funeral was presided over by the Masonic grand master of Virginia. One thousand mourners followed the hearse to the Presbyterian Cemetery on Hardware Street, which was twice the number of people who resided in Scottsville at that time.

24. Jefferies-Bruce House (540 Harrison Street)

In the center of the block on the west side of Harrison Street, between Lindsay and Clements Streets, is the Jefferies-Bruce House. This is a Federal-style house with Greek Revival elements, built about 1838. The house went through a number of owners in its first years, and

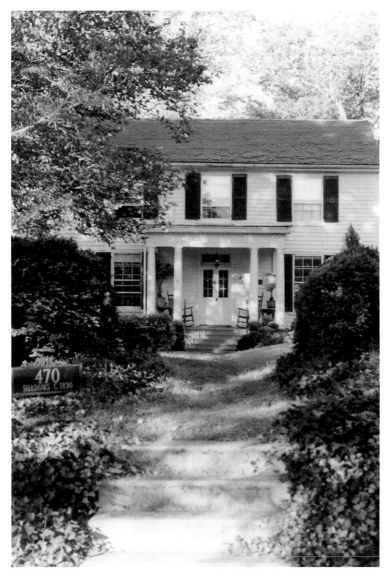

The Shadows, 2001. *Photo by Gwynne Daye; Burgess Collection, Scottsville Museum, Scottsville, Virginia.*

was purchased in 1863 by James M. Jefferies. It was in the Jefferies family until 1919, when Thomas Ellison Bruce bought the house. It is a one-and-a-half-story brick house over an English basement, with a central-hall floor plan, a Tuscan portico and four matching chimneys. Two of the original outbuildings—the nanny quarters and a chicken coop—have survived.

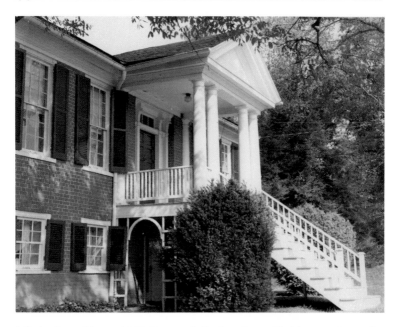

Jefferies-Bruce House, 1969. *Burgess Collection, Scottsville Museum, Scottsville, Virginia.*

25. TIPTON HOUSE (620 HARRISON STREET)

Walk north on Harrison Street and cross Clements Street. On the corner of this block, on the west side of Harrison, is Tipton House. It was built between 1842 and 1844 for William Adams, and was the Blair family home from 1875 to 1927. It is a Federal-style two-story brick house with a Roman tetrastyle portico over a raised cellar.

26. SCOTTSVILLE BAPTIST CHURCH (690 HARRISON STREET)

Farther up this block, on the west side of the street, is the Scottsville Baptist Church. The church was built in 1840 with property and funds donated by Anna Maria (Barclay) Moon and her husband, Edward Harris Moon. The building was remodeled in 1930 to add the four-columned porch. During the Civil War, this building was part of the general hospital in Scottsville. Its first patients arrived on June 24, 1862. The hospital treated 2,236 soldiers during its sixteen-month period of operation.

Members of the early Baptist congregation included the Moons' two daughters, Charlotte (Lottie) and Oriana. Lottie Moon became a famous Baptist missionary in China and translated the Bible into Chinese. Dr. Oriana Moon graduated from the Women's Medical College of Philadelphia in 1857 and, a year later, joined her uncle, Dr. James Turner Barclay, on his Disciples of Christ mission in Jerusalem.

Scottsville Baptist Church, circa 1907. *Photo by the Idylwood Studio (W.E. Burgess), Scottsville, Virginia. Collection of J. Tracy Walker III, Charlottesville, Virginia.*

27. SCOTTSVILLE FACTORY BUILDING (561–571 VALLEY STREET)

Turn left onto Warren Street and go east, passing a number of cottages. Several of these small houses were built in the late eighteenth century. Now cross Valley Street to the east side, and you will see a three-story brick building built about 1850. This building was originally a mill, and was also used as a tobacco factory as late as 1800 and as a braid factory after that. It was part of the Scottsville General Hospital during the Civil War.

28. OLD APOTHECARY SHOP (510 VALLEY STREET)

On the west side of the street, across from the factory, is a two-story brick Greek Revival building built about 1832. It served as a drugstore from 1876 into the early twentieth century. In 1908, Thomas Ellison Bruce took over the business and set up his first drugstore here. The business moved to 330 Valley Street in 1911 and to the former Carlton Hotel in 1928.

29. HARRIS BUILDING (474 AND 476 VALLEY STREET)

South of the Apothecary Shop is the Harris Building, a two-story brick building with dormer windows, built about 1830 or 1840. For many years, Miss Etta Harris ran a "ladies' store" on the street floor of this building.

30. BUTLER FUNERAL HOME (440 VALLEY STREET)

The second building to the south is the old funeral home. It is a two-and-a-half-story brick building of late Victorian design, built around 1890. At one time, the building was the site of Butler's Funeral Home, where Mr. Butler drove a horse-drawn hearse and built the coffins himself.

31. COLUMBIA HOTEL (410–430 VALLEY STREET)

Farther south on this side of the street is the Columbia Hotel, on the northwest corner of Valley and Bird. It was built around 1840. It is a long, two-story, brick Greek Revival building with a central doorway.

32. VICTORY HALL (401 VALLEY STREET; VICTORY THEATER)

Walk south on the east side of Valley Street to the last building in the row. This is Victory Hall, designed by local architect D. Wiley Anderson and finished in 1920. It was built to commemorate the armistice of World War I and to provide a venue for local theatrical productions, as well as traveling vaudeville and theatrical troupes. The hall was constructed of yellowish brick made from John Martin's foundry on the low grounds of old Snowden (across the river) and comfortably sat an audience of over three hundred with an interior similar to an old opera house. Victory Hall also showed motion pictures and was the location for Scottsville High School's graduation ceremonies, local beauty contests and local talent shows. In the 1940s and 1950s, many soon-to-be-famous country music performers played here. In the early 1960s, the building was converted into a municipal building with town offices.

DRIVING TOUR

The historic Scottsville area includes several large estates that were originally some distance outside of the town. You can view them on a driving tour of the outskirts of the town. Please remember that, except for Chester and Oakwood, these are private homes.

33. LEWIS HOUSE (240 WARREN STREET; CURRENTLY CALLED WYNNEWOOD)

North of the Baptist church, Harrison Street intersects at an angle with Warren Street. Follow Warren Street north past three houses on the east side of the road. The fourth house in this block is the Lewis house, built after the Civil War. During the Union occupation of Scottsville, Yankee soldiers camped on this part of the Cliffside property, while Generals Sheridan and Custer resided in the main house on the hill. John O. Lewis, the owner of Cliffside, built this house on the lower section of his property for his daughter, Virginia, upon her marriage to Dr. Adolphus Perkins Bowles.

34. CLIFFSIDE (300 WARREN STREET)

Continue north on Warren Street. Set back from the road in a large yard on the east side of Warren Street is Cliffside. (In the summer, Cliffside may be hidden by the many trees on the property.) It was built by John Lewis II. Though the first parts of the building were constructed in 1785, most of the house was finished in the first decade of the nineteenth century. John Owen Lewis, the son of

Cliffside, circa 1915. *Eleanor Evans Collection, Scottsville Museum, Scottsville, Virginia.*

John Lewis II, lived in the house with his wife and several daughters throughout most of the nineteenth century. It is a two-story house in the Federal style with a central-passage plan, made of brick laid in Flemish bond, over an English basement. In March 1865, Sheridan and Custer chose this house as their headquarters while in Scottsville. It was also the home of Virginia Moore, a nationally known fiction writer and poet and local historian who wrote *Scottsville on the James*, a history of the town. On the Cliffside property is a small one-story frame house called the Ginger House. The Lewis family used this building as a school for their children. Near this house is an early cemetery. (NRHP, VLR)

35. Belle Haven (275 James River Road)
Just past Cliffside, you'll come to the intersection with James River Road. Turn right, then look to your left. This large white mansion is Belle Haven. The wood-frame house is in a late Victorian style and was built about 1880 for an English family named Clark. It was purchased in 1900 by Captain John L. Pitts for his son and daughter-in-law. The Tiffany stained-glass windows are one of the most notable features of this house.

36. Chester (243 James River Road)
http://www.chesterbed.com/services.htm
Follow James River Road east. Chester will be on your right about a fifth of a mile from Belle Haven. The house was built in 1847

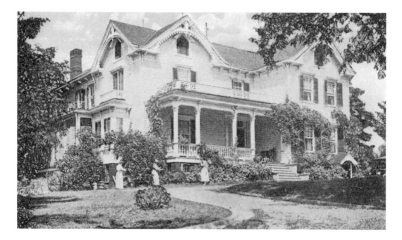

Belle Haven, circa 1915. *Katherine McNamara Collection, Scottsville Museum, Scottsville, Virginia.*

by Joseph C. Wright, a retired landscape architect from Chester, England. In March 1865, during the Union destruction of Scottsville, the house was the home of Major James C. Hill, the local Confederate army commander. Fearing that his home would be damaged and his family endangered, Hill sent a message to General Sheridan asking for leniency because of his illness—he had been wounded in the arm at the battle of Petersburg in 1864. When Sheridan and his aide, General Custer, visited Chester, they decided not to arrest Hill since they thought he was a dying man. Major Hill survived, though his arm was eventually amputated, and after the war, Hill became editor of the Scottsville *Courier* newspaper. Chester is now a bed-and-breakfast.

37. HIGH MEADOWS INN (55 HIGH MEADOWS LANE)
http://www.highmeadows.com
Follow James River Road until it intersects with Route 20, and turn right. You are once again on Valley Street. Driving south, the second street you come to on the east side of the road is High Meadows Lane (it is marked with a sign for the bed-and-breakfast). Turn left here. Originally called Fairview, this brick house embodies two distinct styles. The Federal-style part of the house was built in 1832 for Scottsville surveyor Peter White. In 1882, Charles Bascom Harris Sr. added a Victorian wing, joined to the original structure by a covered hall. High Meadows was a country inn and restaurant from 1985 until it closed in 2006 and was put on the market. It is not currently in operation. (NRHP, VLR)

38. 732 VALLEY STREET
Continue south on Valley Street. Just before you reach the intersection of Valley and Hardware Streets, you will see a row of badly deteriorated

houses on the west side of the street. The northernmost house is 732 Valley Street. The foundation of Scottsville's prosperity in the first half of the nineteenth century was the African slaves and other laborers and artisans who constructed the houses, loaded the boats and wagons and performed all the tasks of daily life for a prosperous business community. There are few examples of worker housing left in Scottsville, and this badly deteriorated structure is one. It is a hall-and-parlor wood-frame building with side gables and a shed-roof porch, built about 1800.

39. 635 Valley Street

A block south on the east side is another example of worker housing. The wood-frame outbuilding of 635 Valley Street is of antebellum construction, as indicated by the square-cut nails and circular-sawn boards. The hall-and-parlor design suggests that it was used as a kitchen for the household and as living quarters for slaves. The walls and floor are of wide wooden boards, with a wood mantel, and some whitewash remains on the walls.

40. Mount Walla (604 Poplar Spring Road)

Continue south on Valley Street and turn left onto Main Street. From this point, Main Street is Route 6, which was the old Richmond Road along the river. You will pass Canal Basin Square and Ferry Street (where Scotts' Ferry crossed the James River) on your right. About nine hundred feet east of Ferry Street, turn left onto Poplar Spring Road. Mount Walla is located on the west side of the road, and is situated on a hill overlooking Scottsville. (Both Mount Walla and Riverview are surrounded by trees and may be difficult to see.) This was originally the home of John Scott, who operated the ferry and other businesses in the village below. The central part of the house was most likely built sometime in the period between 1820 and 1840, although 1770–77 is the traditional date given; it is conceivable that it was built in the late eighteenth century and remodeled in the nineteenth. The story-and-a-half Greek Revival house has a brick foundation and is sided in beaded weatherboards, with a metal-sheathed gable roof and gable-end chimneys. This house was purchased in 1836 by Peter Field Jefferson. There is a small family cemetery on the grounds. (NRHP, VLR)

41. Riverview (600 Poplar Spring Road)

Immediately north of Mount Walla is Riverview. This house was built by wealthy Scottsville merchant Littleberry Moon after his marriage to Sallie Perkins in 1812. Moon probably had his office in the two-story Greek Revival brick house. The original kitchen was separate from the main house, which was typical in that time because of the danger of fire. About 1860, a one-story extension was built to connect the house to the kitchen.

42. SCOTTSVILLE CEMETERY (INTERSECTION OF HARDWARE STREET AND JAMES RIVER ROAD)

Follow Poplar Spring Road for about a mile, to the intersection with Pat Dennis Road. Turn left on Pat Dennis Road, left again on Albevanna Spring Road and then left onto Hardware Street/ Blenheim Road (Route 795). The cemetery will be on your right. The Scottsville Cemetery was originally called the Presbyterian Cemetery. It was established by the church in 1864, and was turned over to a cemetery corporation in 1940. In 2006, there were 1,582 gravestones and several unmarked graves in the cemetery.

43. UNION BAPTIST CHURCH (HARDWARE STREET/ROUTE 795)

Continue south on Hardware Street for three-tenths of a mile. The Union Baptist Church was organized in 1865 by the Reverends Henry Smith and A.J. Doll, and is the oldest black Baptist congregation in Scottsville. The first pastor was Reverend Smith. The original wood-frame building was replaced in 1954 by the current cinderblock building, which was designed by then-pastor Reverend Houston Perry. The church cemetery is just southwest of the church on the same side of Hardware Street.

44. OAKWOOD (180 HARDWARE STREET)

http://www.oakwoodbb.com

Continue south on Hardware Street to Oakwood, which will be on your right. This property was purchased by John Weems Gantt between 1835 and 1840, and inherited by his son, Thomas Perkins Gantt, in 1860. The original house burned in 1871. The current house was built in 1900 in the Colonial Revival style. It has a hipped roof and a wraparound porch with Doric columns. Oakwood is currently a bed-and-breakfast.

45. CONFEDERATE CEMETERY AND MARKER (CONFEDERATE STREET)

Continue south on Hardware Street for a tenth of a mile and look for Confederate Street on your left. Parking is available on Valley Street a block west of the cemetery. This cemetery contains the graves of forty Confederate soldiers who died at the Scottsville General Hospital between 1861 and 1865, and a monument placed there by the Scottsville Chapter of the United Daughters of the Confederacy in 2001.

SIDE TRIP

46. VALMONT (VALMONT LANE)

Follow James River Road past Belle Haven until you see Valmont Lane on the east side of the road. At the top of the hill was the original house on Edward Scott's 1732 grant, and the place where Albemarle County was organized in February 1744/45. Though the

old Albemarle Courthouse no longer exists, and the site cannot be definitively ascertained, it was located nearby. After the Scotts, the property was owned by John Weems Gantt (see number 44 above) and inherited by his son, Captain Henry Gantt. Captain Gantt was the commander of the Scottsville Guard, which became one of the units of the Virginia Nineteenth Infantry.

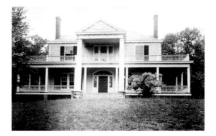

New Valmont, circa 1920s. *Raymon Thacker Collection, Scottsville Museum, Scottsville, Virginia.*

The current house was built after the Civil War, replacing the original that was burned down by Union forces in 1865.

47. Totier Creek Reservoir (James River Road)

Farther west on James River Road is Totier Creek Reservoir, a sixty-six-acre lake and reservoir managed by the Virginia Department of Game and Inland Fisheries. It is a good fishing lake, providing largemouth bass, bluegill, redear sunfish and channel catfish. There is a well-maintained boat ramp and public parking.

Tour—The Monacan Indian Museum and the Frontier Culture Museum

1. Monacan Indian Nation Ancestral Museum, Amherst (2009 Kenmore Road)

http://www.monacannation.com

Until fairly recently, historians thought that the Monacan had left the central Virginia area long before Europeans began to settle here. Current archaeological evidence indicates that the Monacan began to move out of Albemarle County around 1670, and by the early eighteenth century, few individuals remained. However, a group of Monacan settled near Bear Mountain in Amherst County, Virginia, and their descendants live there to this day. If you are in the area the third weekend in May, you can attend the Annual Monacan Powwow.

Also in this area is the Bear Mountain Indian Mission School (NRHP, VLR), located at the intersection of Indian School Road (Route 780) and Kenmore Road (Route 643). This mission was established in 1908 by the Episcopal Church to provide education for the Monacan children in the area. To the west of the log school is Saint Paul's Episcopal Church, which dates from about 1930, having replaced the original church that burned in the winter of that year. The oldest school building is a single-story, one-room, horizontal log structure that predates the original mission by about forty years (about

1868) and had been used for other purposes by the community before it became a school. This site is significant because it is one of the few mission schools for Native Americans surviving in Virginia, and is representative of the segregated public schools that populated the Reconstruction South.

2. FRONTIER CULTURE MUSEUM OF VIRGINIA, STAUNTON (1290 RICHMOND ROAD)
http://www.frontier.virginia.gov/
The Frontier Culture Museum is an outdoor living-history museum. The museum currently features six permanent outdoor exhibits of original farm buildings from England, Germany, Ireland and Virginia. These buildings have been carefully documented, dismantled, transported and restored. The museum uses these farms to provide interpretative and educational programs to increase public knowledge of the diverse Old World origins of early immigrants to America and how the European settlers interpreted their origins when they arrived in Virginia.

READ MORE ABOUT IT

Moore, John Hammond. *Albemarle, Jefferson's County, 1727–1976.* Charlottesville: Albemarle County Historical Society, 1976.

Moore, Virginia. *Scottsville on the James: An Informal History.* Charlottesville: Dietz Press, 1994.

Phillips, John Randolph. *Of Town and the River, A Folk History of Scottsville, VA.* 250th anniversary ed., revised by Robert Kirkwood Spencer. Charlottesville: King Lindsay Printing, 1994.

Chapter 3

Central Virginia in the Revolution (1775–1783)

To the British, the rebellion in North America was a small fire that could easily be extinguished. After the April 19, 1775 skirmish at Lexington and Concord, in which local militias attacked a unit of the king's army, the military governor of Massachusetts, Sir Thomas Gage, issued a proclamation offering a pardon to all Bostonians who would lay down their arms and return to being peaceful citizens—excepting only Samuel Adams and John Hancock, whose actions he considered too inflammatory to pardon. This offer of amnesty offended many colonists by its patronizing tone and caused many who were wavering to turn to the Rebels' side.

In May 1775, the Second Continental Congress met in Philadelphia. Among the Virginia delegates was Albemarle resident Thomas Jefferson, then only thirty-two. In the First Continental Congress, Jefferson had written the instructions to the Virginia delegation, later published in 1774 as *A Summary View of the Rights of British America*. Though the colonists had already fielded an army under the command of General George Washington, the Congress wavered for the next year between attempting to diplomatically resolve the problems that had come between the colonies and the royal government and declaring the colonies' independence from Great Britain. In May 1776, the Virginia delegation was instructed to present a motion for the Congress to "declare the united colonies free and independent States." This resolution was adopted, and Jefferson was assigned to write the declaration.

When the time came to sign the Declaration of Independence, each man there knew that by signing the document, he was committing treason against the Crown. As foreshadowed in Gage's Proclamation, the British government would continue to target these high-profile men in order to make examples of them. In fact, over half of the signers of the declaration suffered serious economic and personal losses as a result of their service to the colonies throughout the Revolution. The Virginia delegates were no exception.

THE CONVENTION ARMY

At the Battle of Saratoga in New York, which took place over a month in September and October of 1777, the American force overwhelmed the British army led by General John Burgoyne. After a week of negotiation, Burgoyne surrendered his army of six thousand men—both British Regulars and German mercenaries[28]—on October 17. This victory showed the world that the Americans could fight a European army and win. It was a turning point in the Revolution, in that it convinced the French to ally themselves with the Americans.

The document of surrender, called the *Convention of Saratoga*, allowed the men "the Honors of War" and required them to surrender their weapons and not to fight against the Americans again during this conflict. The convention also allowed officers to be paroled or exchanged, and stipulated that the rest of the army was to be sent home when transport was available. Until that could be arranged, the "Convention Army," as it was called, was quartered in Boston. After several months, it became clear that Sir Henry Clinton, commander in chief of the British forces in North America, would not allow American vessels passage to Boston to provide provisions and fuel for the use of the convention troops. In addition, the authorities in Great Britain were procrastinating in signing the conventions to which Burgoyne had agreed. In late 1778, Congress felt justified in revoking the terms of the convention. At the suggestion of the representatives from Virginia, the four thousand men remaining in the Convention Army were moved seven hundred miles south to Charlottesville, Virginia, and John Harvie, another Albemarle County member of the Continental Congress, offered the use of his land outside the town to quarter the prisoners. Harvie requested and received $23,000 to build barracks to house the prisoners on the property on the north side of Ivy Creek.

Historian Louis Hue Girardin stated,

> The situation of Charlottesville was well adapted to the double purpose of subsistence for the troops, and of security against their escape. The Convention prisoners might easily be supported at that place…Here then was an immense field, whose surplus of produce could not be carried to the American army, a field too, that could be made to produce much more…The town of Charlottesville itself was surrounded by mills…The safe custody of the troops was another circumstance for which the site of Charlottesville appeared extremely well-fitted—equally removed from the access of an Eastern or Western enemy, placed in the very heart of the State, so that should the prisoners attempt an eruption in any direction, they must pass through a greater extent of hostile country, in a neighborhood thickly inhabited by a robust and hardy people. Zealous in the American cause, acquainted with the use of arms; the defiles and passes by which they must issue, ever watchful, ever ready to crush in its birth any improper movement on the part of the prisoners.[29]

Thomas Jefferson called the winter of 1779 "the worst ever known within memory of man," and the prisoners, after having left Boston in November 1778 and marched through the winter, arrived in an unseasonal (for Virginia) January blizzard.[30] The last division arrived at the barracks on January 19, 1779. Of the 4,145 men who had begun the march, about 3,750 reached Virginia; the missing men were mostly deserters who had found a way to escape along the route.

Harvie had delegated the work of setting up the Convention Army's barracks to a brother who had not followed through with the work. When the prisoners first arrived at the Albemarle barracks some six miles west of Charlottesville "a momentary embarrassment was felt [by the local residents], and the people experienced some alarms at the consequences which a want of necessary accommodations might produce. The winter was uncommonly severe: the barracks unfinished for want of labourers; no sufficient stores of bread laid on; and the roads rendered impassable by the inclemency of the weather and the number of wagons which had lately covered them."[31]

Thomas Anburey,[32] one of the British officers in the Convention Army, told of his arrival at Charlottesville that winter.

[Written at] *Jones's Plantation, near Charlottesville, in Virginia, Jan. 20, 1779. After we left Frederick Town, we crossed the Potowmack River* [at Noland's Ferry] *with imminent danger, as the current was very rapid, large floats of ice swimming down it, though the river was only half a mile wide, the* [scow] *that I crossed over in had several narrow escapes…*

The difficulty of crossing was only a fore-runner of the hardships and fatigues we were to experience on our entering Virginia, for on our march to this place, the men experienced such distresses, as were severe in the extreme; the roads were exceedingly bad from the late fall of snow, which was encrusted, but not sufficiently to bear the weight of a man, so we were continually sinking us up to our knees, and cutting our shins and ankles, and, perhaps, after a march of sixteen or eighteen miles in this maner [sic], *at night the privates had to sleep in woods; after their arrival at the place of destination, the officers had to ride five or six miles to find a hovel to rest in.*

But on our arrival at Charlottesville, no pen can describe the scene of misery and confusion that ensued; the officers of the first and second brigade were in the town, and our arrival added to their distress; this famous place we had heard so much of, consisted only of a Court-house, one tavern [the Swan], *and about a dozen houses; all of which were crowded with officers, those of our brigade therefore, were obliged to ride about the country, and entreat the inhabitants to take us in.*

As to the men, the situation was truly horrible, after the hard shifts they had experience in their march from the Potowmack, they were, instead of comfortable barracks, conducted into a wood, where a few log huts were just begun to be built, the most part not covered over, and all of them full of snow; these the men were obliged to clear out, and cover over to secure

themselves from the inclemency of the weather as quick as they could, and in the course of two or three days rendered them a habitable, but by no means a comfortable retirement; what added greatly to the distress of the men, was the want of provisions, as none had as yet arrived for the troops, and for six days they subsisted on the meal of Indian corn made into cakes. The person who had the management of every thing, informed us that we were not expected till Spring.[33]

Lieutenant Auguste Wilhelm Du Roi, a Brunswicker, wrote,

Most of [the barracks] *did not even have a roof. The first impression was especially bad as it had been snowing hard when we arrived. A great number of our men preferred to camp out in the woods, where they could protect themselves better against the cold than in the barracks. Never shall I be able to forget this day, which was terrible in every way. Never had I seen men so discouraged and in such despair as ours, when, tired and worn out from the long trip and the hardships, they had to seek shelter in the woods like wild animals.*[34]

Anburey also relates that because the suitable housing was full in the Charlottesville area, the remaining officers were asked to sign a parole guaranteeing that they would not attempt to escape, and were allowed to roam the countryside, sometimes as far away as Richmond, in order to find lodging. This freedom to roam was later curtailed so that the officers were kept closer to home in order to oversee the enlisted men's activities and behavior. Many of the locals saw the opportunity to make some money, and so rented out rooms and houses to groups of officers. As time went on, some officers built cabins for themselves in the area around Charlottesville.

Major General William Phillips, commander of the British troops in the Convention Army, and Baron von Riedesel, commander of the German troops, arrived in Charlottesville in February 1779. Phillips took residence at Blenheim, the home built by Secretary John Carter on his property in Albemarle County. Riedesel, accompanied by his wife Friederike and their three young daughters, rented the house at Colle from Philip Mazzei. Living only a mile apart, the Riedesel family and the Jefferson family became great friends during their brief stay, exchanging visits frequently for dinner and musicales.

The prisoners seemed up to the challenge of creating a livable camp, and within a few months had cleared the trees on six square miles of land for timber to build huts, chicken coops, livestock pens and a theater, and to plant kitchen gardens to supplement the short rations given them. Friederike von Riedesel wrote,

The troops were…three hours ride from us, and the road thither ran through a fine wood. At first they suffered many privations; they were billeted in block houses, without windows or doors, and but poorly protected from the

cold. But they went diligently to work to construct better dwellings, and in a short time the place assumed the appearance of a neat little town. In the rear of each house they had trim gardens and enclosed places for poultry. They wanted [lacked] *nothing but money.*[35]

Though the officers, and especially the generals, were fêted and lionized by Albemarle society, the common soldiers did not fare so well. Anburey wrote, in December 1779, "Although we have been now near a twelvemonth in this province, the soldiers fare little better than on their first arrival; for the greatest part of the summer they have been thirty or forty days, at different periods, without any other provision delivered to them than the meal of Indian corn."[36] The salted meats delivered to the barracks were spoiled by the heat, and although General Phillips complained to Jefferson, now governor of Virginia, he was told that the matter was the concern of Congress, not the state of Virginia. Both Phillips and Riedesel were exchanged in September 1779 and returned to New York, where they intended to appeal to General George Washington for redress of these grievances.

Anburey reported that, because of these hardships, many of the British troops deserted and attempted to get to New York, where they could find refuge with Sir Henry Clinton's army. Many of them told their officers of their intentions prior to their desertions and requested certificates stating what pay and clothing was due to them as of a specific date, so they would have evidence of their service. "To be candid, rather than be witness of the hardships the men experienced, which were out of our power to redress, we [the officers] rather connived at it…Near a hundred have reached New-York, and about sixty or seventy have been taken up, brought back and confined in a picketed prison near the barracks, where numbers would have actually been starved" had not the officers furnished them with provisions at their own expense. He reported that the German troops didn't seem to want to leave the area, "for what reason it is impossible to say, but the Americans shew more indulgence to the Germans."[37] By March 1780, due to attrition by exchanges, escapes and deaths, only 2,257 men were left in the camp—1,068 British and 1,189 Germans.[38]

In the fall of 1780, British General Lord Cornwallis overran the Carolinas, capturing the port of Charleston and a good number of the Continental army troops, and began to march his men north to Virginia, which had seen only minor military action on its soil since the early days of the war. Congress, aware that having a large number of enemy soldiers in central Virginia would be dangerous if Cornwallis was successful in his efforts to take Virginia, determined that the remaining convention troops should be moved away from the expected fighting.[39] In November 1780, the remaining 804 British troops were marched northwest to Fort Frederick, Maryland, about

thirteen miles west of Hagerstown. The German troops were not moved until late February 1781, and were sent first to Winchester, Virginia, and then to Fort Frederick. During their long stay, many of the soldiers had decided to settle in America, and by the end of the war, the Convention Army had dwindled to 1,500 troops, who were released in 1783.

THE BRITISH INVASION OF VIRGINIA

Thomas Jefferson succeeded Patrick Henry as governor of Virginia on June 1, 1779, and served for two one-year terms. He moved the capital of Virginia from Williamsburg to Richmond in April 1780, because of the vulnerability of Williamsburg's location to invasion. On December 30, 1780, Benedict Arnold, the Continental hero of Saratoga—by then a British general—landed a regiment of one thousand British troops near Westover, and immediately attacked Richmond. Governor Jefferson attempted to call in the militia, but the men did not arrive in time to resist this new British incursion. Jefferson employed some of the militiamen to save the records and papers of the legislature and to move the military stores to a site across the James River. He could be seen encouraging the men in this work until Arnold's forces actually entered the southern part of the city, and he remained in the area throughout the invasion, at great personal risk. The British proceeded to burn the foundry, the boring mill, the weapons magazine, papers of the auditor's and council offices and some private homes, and then retreated back down the river to Portsmouth, where the army stayed for the month of January 1781.

Throughout the first months of 1781, Jefferson continuously wrote to Congress asking for assistance in the form of weapons and men. He got no response. In February, General Phillips, who had resided in Charlottesville with the Convention Army not too long before, arrived with additional troops to reinforce Arnold's regiment. The two generals immediately set out to cause as much trouble and damage as they could, and captured and laid waste to Williamsburg, Petersburg and several surrounding villages. For the next several months, Arnold and Phillips occupied the area between Portsmouth and the fall line, causing a great deal of destruction and, in general, keeping busy what Continental and militia troops were available.

An early biographer of Jefferson wrote,

Ever since the invasion of [Richmond] *under Arnold in January, 1781, and the sudden dispersion by that event of the General Assembly, the legislative functions of the government had been almost totally suspended. The members had re-assembled on the first of March, but after a few days' session, were compelled to adjourn. They met again on the 7th of May, but the movements of the enemy again compelled them on the 10th to adjourn to Charlottesville to meet on the 24th.*[40]

Jefferson's second term as governor ended on May 30, and though he refused to accept a third term, Jefferson served as the acting governor of Virginia for the first few days of June because the legislature had yet to elect a new governor.

On May 20, 1781, Lord Cornwallis crossed the southern border of Virginia with his army of four thousand troops that had just overwhelmed the Continental forces in the Carolinas. Combined with Arnold's troops (Phillips had died earlier that month), the British forces in Virginia now numbered about seven thousand. Arrayed against them to protect Virginia were nine hundred light infantrymen under the Marquis de Lafayette and one thousand militiamen under the command of General "Mad Anthony" Wayne.

As Lafayette and Wayne retreated before Cornwallis's army, the British moved north of Richmond to Hanover Junction on the North Anna River, and from there Cornwallis sent two forces to strike into the heart of Virginia. One force, under Lieutenant Colonel Simcoe, was aimed at capturing the military stores at Point of Fork, the confluence of the James and Rivanna Rivers, now called Columbia. On June 3, Lord Cornwallis ordered the second force, Lieutenant Colonel Banastre Tarleton's 180 dragoons and Captain Kenneth McLeod's 70 mounted infantry troops, to go to Charlottesville and attempt to capture the entire Virginia General Assembly, especially the traitors who had signed the Declaration of Independence.

Tarleton intended to move quickly in order to surprise his quarry. In fact, they moved *very* quickly, covering the seventy miles from Richmond in twenty-nine hours. On the evening of June 3, an Albemarle County militia captain named John ("Jack") Jouett Jr.[41] happened to be at Cuckoo's Tavern in Louisa County when Tarleton's troops stopped for a rest. Jouett realized what their objective was and quietly set off to warn Jefferson and the other legislators of this approaching danger. Assuming, correctly, that Tarleton's group would follow the main Louisa road, Jouett avoided them and saved time by going cross-country and using an overgrown former trail to reach the Three Notch'd Road. Crossing the Rivanna at Milton, Jouett arrived at Monticello about dawn on June 4, informed Jefferson of the news and then rode for Charlottesville to warn the rest of the legislature. Reaching his father's tavern next to the courthouse, he changed into a flashy scarlet coat with a military hat and plume, mounted a fresh horse and led British troops on a fruitless chase over the countryside while most of the legislators got away.

Jefferson and his household had "a leisurely breakfast," and then the several legislators who were staying with him (including Thomas Nelson Jr., Richard Henry Lee and Benjamin Harrison, each of whom had also signed the Declaration of Independence) left for Charlottesville to adjourn the legislature, so it could reconvene in Staunton on June 7. Jefferson then sent his wife and children off to a friend's plantation.[42] Evidently thinking he had plenty of time to escape, Jefferson stayed

at Monticello for another couple of hours, hiding the papers of state and other valuables. Receiving a second warning from a neighbor that a troop of British soldiers was on its way up the mountain, Jefferson quickly mounted his horse and left Monticello just as the British Captain McLeod led his force up the mountain to capture him, and then rode cross-country to join his family.

Meanwhile, Tarleton's forces had stopped along the way several times, first to capture and burn a wagon train carrying munitions and supplies to the Continental forces, and later at Belvoir and Castle Hill plantations to rest the horses and capture several legislators staying at those places. They easily defeated a small militia force and crossed the Rivanna at Secretary's Ford, invading Charlottesville by way of the Three Notch'd Road. Because of Jouett's warning, the British only succeeded in capturing a few legislators, among them Daniel Boone. The British troops bivouacked that night at the Farm, the home of the Lewis family, near Charlottesville, where the captive legislators were imprisoned in the coal cellar.

The next day, June 5, Tarleton and his forces destroyed irreplaceable public records and military supplies and arms stored at the Albemarle Courthouse in Charlottesville. Taking the legislators and about twenty ex-prisoners from the Convention Army, Tarleton then retreated to Point of Fork, where the British had succeeded in capturing the arsenal and had encamped at Jefferson's Elk Hill plantation nearby. The captive legislators were taken to Elk Hill with Tarleton, kept in custody for a brief time and then paroled.

About a week later, Cornwallis sent Tarleton's small force to destroy Continental supplies that were missed in the first raid, having been stored in the Old Albemarle Courthouse at Scott's Landing. In Culpeper, the Marquis de Lafayette, joined by General Wayne and his troops, got word of this action and, in a forced march, quickly got as far as Boswell's Tavern in Louisa County, only to find that Tarleton was between him and Scottsville.

> There was a rough road, long disused [the same overgrown trail that Jouett had followed on horseback the week before], leading from Boswell's to a point on Mechunk Creek; forthwith Lafayette set to work his pioneers and axemen; the road was opened, the army passed along it, and the next morning…his [Tarleton's] adversary was encamped in an impregnable position on the Creek [near Giles Allegre's Tavern], and just between the British Army and the stores at the Albemarle Court House! [43]

Seeing that his small force stood no chance against Lafayette's and Wayne's troops, Tarleton retreated to rejoin Cornwallis's army. The road that Lafayette opened that night has been called the Marquis Road since that day. On June 14, Cornwallis left Elk Hill, going east.

The Virginia Legislature, meeting in Staunton, honored Captain Jouett for his actions when they reconvened. On June 15, 1781, they

voted to reward Jouett with "an elegant sword and a pair of pistols" for his "enterprize in watching the motions of the Enemy's Cavalry on their late incursion to Charlottesville, and conveying to the Assembly timely information of their approach, whereby the designs of the Enemy were frustrated, and many valuable stores preserved."[44] Jouett received the pistols in 1783 and the sword in 1803. In 1782, Jack Jouett moved west to what is now Kentucky, married and had a family. He later served in the Virginia and Kentucky Legislatures and was active in the effort to make Kentucky a state. He died on March 1, 1822.[45]

In late July 1781, Cornwallis and his army pulled back from central Virginia and Richmond to Yorktown, and waited there to receive reinforcements from Sir Henry Clinton in New York. Throughout August, Lafayette and Wayne pursued the British southeast, and under orders from General Washington, kept the British from moving either north or west. About the same time, Washington began moving troops south from the New York theater of operations, and the French Admiral de Grasse and the British Admiral Graves headed their fleets to the Chesapeake Bay. De Grasse arrived first, and over September 5–6, the French fleet blocked the British fleet from landing its reinforcements. In late September, the allied armies (Continental, French and local militias) had gathered a force about twice the size of the eight thousand British troops at Yorktown. For three weeks, the allied forces besieged the city, preventing British attempts to break out of the blockade. On October 19, 1781, Lord Cornwallis surrendered to General Washington, and for the most part, the fighting in the American Revolution ended. The peace was made official by the Treaty of Paris in 1783.

Tour—Revolutionary Trails

This drive takes you along roads that were used over two hundred years ago by the American and British forces. Many of the buildings on this route are privately owned homes and are not open to the public unless otherwise indicated.

1. Cuckoo's Tavern site (Pendleton-Wooton House)
Begin at the site of Cuckoo's Tavern at the crossroads of Virginia Routes 33 and 522. The current house called Cuckoo was built about 1812 for Henry Pendleton, and historians believe it was built on the original foundation of the old Cuckoo Tavern. This house is still owned by descendants of the Pendleton family. The tavern, which may have belonged to John Jouett Sr. before he moved to Charlottesville to open the Swan Tavern, was a well-known stopping place for travelers in the eighteenth century. It was from this location that Jack Jouett Jr. began his late night ride to warn the Virginia Legislature that Tarleton's dragoons were on their way. (NRHP, VLR)

From here, you can follow Jouett's route, starting with number 2 below, or Tarleton's route, starting with number 17 below. Both routes will end in Charlottesville.

JOUETT'S ROUTE

Assuming (correctly) that Tarleton would take the well-known road west through Louisa to get to Charlottesville, Jack Jouett left Cuckoo about 11:00 p.m. on June 3 and took the shorter route across country to reach the Old Mountain Road. This old road was neglected and overgrown, but luckily Jouett was familiar with the territory, for the moon was new and there was little light to go by. We don't have a record of the exact route that Jouett took, but some historians believe the following is as close to Jouett's route as we can get on modern roads.

2. IONIA FARM (ROUTE 640)
From Cuckoo, turn west onto Route 522 and take an immediate right onto Cuckoo Road (Route 643). At Goodwin's Store, turn left onto Shannon Hill Road (Route 605). Follow Route 605 until you come to the Old Mountain Road (Route 640), and take a right. Follow Route 640 to Butler's Store, and take a left onto Route 208. At Bell's Crossroads, turn right onto Route 640, at this point called East Jack Jouett Road. From this point Route 640 is a well-maintained gravel road. Watch for the one-lane bridge. Ionia Farm on Route 640 was built by Major James Watson in 1770. (NRHP, VLR)

3. GREEN SPRINGS NATIONAL HISTORIC LANDMARK DISTRICT
http://www.cr.nps.gov/nr/travel/journey/ghd.htm
Follow Route 640 until it meets Green Springs Road (Route 617) and take the left fork onto that road. Route 617 from here to Route 615 is a well-maintained gravel road with one-lane bridges over the creeks. Green Springs National Historic Landmark District is a 14,000-acre agricultural area in Louisa County that contains thirty-five historic homes on the National Register of Historic Places and 8,000 acres under conservation easement. It is bounded by Routes 15 and 22. A brochure about the district is available at Maddox Store, at the corner of Route 613 and Route 640, and the district and homes can be viewed from the roads. One of the houses you can see from Route 617 is Green Springs, built in 1772 by Richard Morris. (NRHP, VLR)

4. HAWKWOOD (ROUTE 615)
Route 617 crosses Route 15 with a right-hand jog, and soon meets Columbia Road (Route 615). Turn left onto Route 615. On this road you will see Hawkwood, designed by Alexander J. Davis. It is an Italian villa–style house built in 1855, and until it burned in 1982, the best example of the style in Virginia. Hawkwood's "ruins" are actually

inhabited, and the owner is gradually restoring the house. (NRHP, VLR)

5. THREE NOTCH'D ROAD AND MECHUNK CREEK

At Zion Road (Route 627), take a right. You are now on a piece of the original Three Notch'd Road. Route 627 runs into Route 250; take a right onto Route 250. Watch for Mechunk Creek just before the Albemarle/Fluvanna County line. Near here was Allegre's Tavern; Lafayette and his forces camped in this vicinity to protect the supplies that were stored in the Old Albemarle County Courthouse in Scottsville.

6. BOYD'S TAVERN

Soon after you see Mechunk Creek, look for Route 759 on the south side of Route 250, and take a left onto another section of the original Three Notch'd Road. Follow this road in a semicircle past Boyd's Tavern. This tavern was run by Thomas and Mary Magruder Boyd, and was a stop on Lafayette's route on his grand tour of the United States in 1824. The original tavern burned in 1868, but was

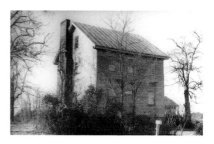

Old Boyd's Tavern, date unknown. *Milton Waff Collection, Albemarle Charlottesville Historical Society, Charlottesville, Virginia.*

rebuilt with the original chimneys on the same foundation (NRHP, VLR). As you cross the county line, the road becomes Route 616 and intersects with Route 250.

7. MILTON

Take a left onto Route 250. Mrs. Boyd of Boyd's Tavern was the aunt of Benjamin Harrison Magruder, who owned Glenmore Plantation, which you will pass on the south side of Route 250. Just after you pass an entrance sign for the gated community of Glenmore that has been built on the property, the original house is barely visible from the road, in a copse of trees. About a mile past Glenmore, turn left onto North Milton Road (Route 729). On the east side of North Milton Road, you will see Collina Farm and Clifton, both historic bed-and-breakfast inns (http://www.cliftoninn.net/). Originally the site of a warehouse in a Randolph business venture at Milton, Clifton was the home of Thomas Mann Randolph Jr., Thomas Jefferson's son-in-law, from 1826 to 1828. Offended at not being named executor of Jefferson's will, Randolph separated from his family, who lived at Edgehill, and moved to Clifton. Randolph moved to the North Wing at Monticello in March 1828, and died there, alone, in June 1828.

Jouett crossed the Rivanna at the Shallows at Milton. Just before you cross the bridge over the river, you'll see Randolph Mill Road on your left. This is a public boat landing and was probably the site of the actual ford. Standing on the north bank of the river at this landing, you can look across and see a faint path leading up the hill, all that remains of the old road leading to Milton.

8. SIMEON

Turn right onto Route 732. The land on your right along this road is Tufton, one of Thomas Jefferson's farms. It belongs to the Thomas Jefferson Foundation and is open for special events. (Check the Monticello website for a schedule.) You will pass a small stone building on your left where Route 732 meets Route 53. This was the Simeon Post Office, named for longtime postmaster Simeon Marshall who lived in Colle. It is now home to a restaurant and catering business.

9. COLLE AND JEFFERSON VINEYARDS (1353 THOMAS JEFFERSON PARKWAY)

http://www.jeffersonvineyards.com/

Turn left at Simeon to follow Thomas Jefferson Parkway (Route 53) east. Just after you pass the stone building, look to your left. At the far end of a long lawn you will see Colle. Colle was originally a farm owned by Phillip Mazzei, an Italian who came to Virginia at the request of Thomas Jefferson in order to establish a vineyard on this property. He was appointed ambassador of the United States to the European countries and leased his property at Colle to General Riedesel and his family in 1779. The original house at Colle was so rickety that Riedesel had to pull it down and rebuild the house at his own expense, for fear that a strong wind would bring it down about his ears. The house that the Riedesels built was razed in 1933; the house that you see now was built on the original footprint of that eighteenth-century building.

In 1898, author Paul Leicester Ford stayed at Colle while writing his novel *Janice Meredith* (1899), which sold 200,000 copies, making it the best-selling novel of the day. It was immediately made into a play and was staged in 1901–02. In 1924, *Janice Meredith* was made into a silent film, starring Marion Davies. Tragically, Ford was murdered by his brother in 1902.

Though Colle is a private residence, you can visit

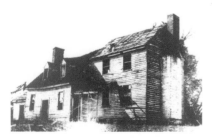

Colle, Simeon, Virginia, circa 1930.
Milton Waff Collection, Albemarle Charlottesville Historical Society, Charlottesville, Virginia.

Jefferson Vineyards a bit farther on to the right, where you can tour the winery and enjoy tastings. The vineyard was built on land that was the Colle vineyard.

When you leave Jefferson Vineyards, turn left and follow Route 53 toward Monticello. (Side trip: If you wish to visit Ash Lawn–Highlands, the home of President James Monroe, turn right as you leave the vineyard; the Monroe home is about two miles to the west.)

10. Kenwood (1329 Kenwood Farm)
http://www.monticello.org/icjs/kenwood.html
Kenwood is the home of the Robert H. Smith International Center for Jefferson Studies and the location of the Jefferson Library, a scholarly research library belonging to the Thomas Jefferson Foundation. The library is open to all researchers of Jefferson and his time. This house was built about 1939 for Major General and Mrs. Edwin M. Watson on land that had belonged to Jefferson. Watson was a secretary and personal friend of President Franklin D. Roosevelt, who used Kenwood as a retreat from the pressures of government. The Watsons had a small cottage built at Kenwood for the president in 1940–41, but he stayed there only once, preferring to join the activity in the main house.

11. Monticello
http://www.monticello.org/
Monticello (pronounced "Monti-CHEL-lo") was the home of Thomas Jefferson, the writer of the Declaration of Independence and the third president of the United States. He lived there, when he was not away because of his public duties, beginning in 1770, when he brought his bride, Martha Wayles Skelton, home to a small, one-room brick building, the only building that was finished. He died at Monticello on July 4, 1826. When you visit Monticello, you will be able to tour the house, gardens, Mulberry Row (the slave quarters and plantation businesses) and the family cemetery. The Thomas Jefferson Foundation has just acquired Montalto, another property that Jefferson owned, and offers tours of that mountaintop for an extra charge. Montalto has a lovely view of Charlottesville and the central valley. (WHL, NRHP, VLR)

Leaving Monticello, take a right onto Route 53. You are on Carter's Mountain, land originally owned by Secretary of Virginia John Carter. This pass over the mountain is called Thoroughfare Gap; it is the only pass over the central section of the Southwest Mountains.

Jouett delivered his warning to Jefferson about 4:00 a.m. on June 4, 1781. He then rode down to Charlottesville along this route to warn the general assembly of Tarleton's expected arrival.

12. Michie Tavern (683 Thomas Jefferson Parkway)
http://www.michietavern.com/
South of Monticello on Route 53 is Michie Tavern, originally located in Earlysville on Buck Mountain Road (seventeen miles northwest of

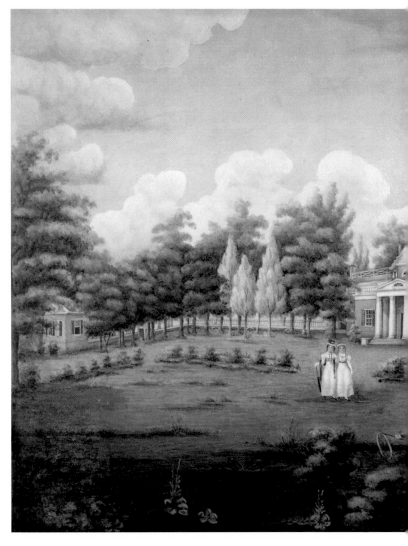

View of the west front of Monticello and garden, circa 1825; attributed to Jane Pitford Braddick Peticolas (1791–1852). *Courtesy of Monticello/Thomas Jefferson Foundation, Inc.*

Charlottesville). The structure was built as a private home about 1735. John Michie (pronounced "Mickey") bought the home and a small tract of land in 1763. He enlarged the house, and his descendants occupied and used it until 1910. In 1784, his son, William Michie, converted the building into an ordinary or tavern. This tavern was typical of taverns in central Virginia in the eighteenth and early nineteenth centuries. There being no hotels—and few buildings of any kind—the numerous taverns provided food, drink and lodging for locals and travelers. It was relocated to this site as a part of the 1920s Preservation Movement

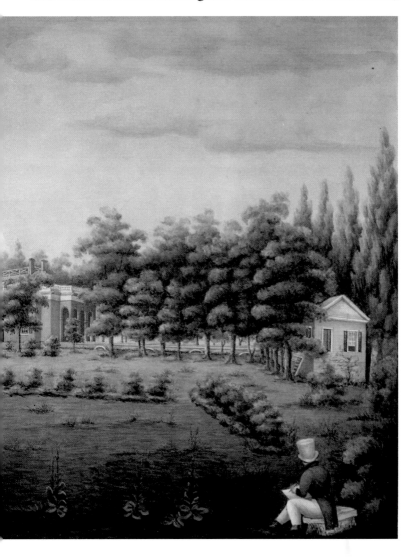

and was restored in 1927. The Meadow Run Mill and General Store was built in 1797, and was reconstructed at this new site in 1996. It is open daily for lunch, year-round. (NRHP, VLR)

13. CARTER MOUNTAIN ORCHARD (1435 CARTERS MOUNTAIN TRAIL)
http://www.cartermountainorchard.com/
Just south of Michie Tavern, on the left, is the road to the orchards on top of the mountain. Open from July through December, the Carter Mountain Orchard sells fresh fruit grown on the mountain and in Chiles' Orchard in Crozet, and allows you to pick your own apples if you feel energetic. You can see wonderful views both east and west from this mountaintop.

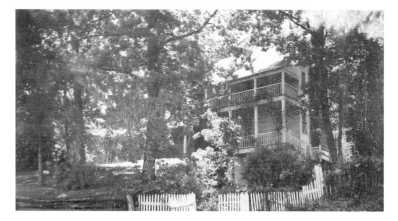

Michie's Old Tavern, Charlottesville, Virginia, circa 1905–08. *Author's collection.*

14. Kemper Park and Saunders-Monticello Trail
http://www.monticello.org/parkway/overview.html
The Thomas Jefferson Parkway provides a scenic entrance to Monticello. It begins at the intersection of Route 53 and Route 20, with the eighty-nine-acre Kemper Park. The primary features of the park are the Saunders-Monticello Trail, a two-mile trail that begins in the park and ends at the Monticello Transportation Center; an arboretum; a two-acre pond; an entrance to Secluded Farm and its trails; and the Carter Overlook.

15. Monticello Visitor's Center
http://www.monticello.org/visit/vc_tours.html
Take a right turn at Route 20. This is the old Secretary's Mill Road, now called Monticello Road. At the next light, there will be a sign for the Visitor's Center and Piedmont Virginia Community College. Turn left here, then make an immediate right into the Visitor's Center parking lot. This center features a permanent exhibit about domestic life at Monticello entitled "Thomas Jefferson at Monticello"; a film, *Thomas Jefferson: The Pursuit of Liberty*; special learning opportunities at the Learning Center; and a gift shop.

16. Court House Square
Follow Monticello Road north into Charlottesville, and take a right at Avon Street. Follow Avon Street to High Street and take a left. Go three blocks and you will cross Park Street. To your right is Court House Square. You can start the Charlottesville original town tour here (Chapter 4).

Jack Jouett stopped in Court House Square, where the general assembly was meeting, to warn the members. Then he went to his father's Swan Tavern, changed into a fancy red coat, mounted a fresh

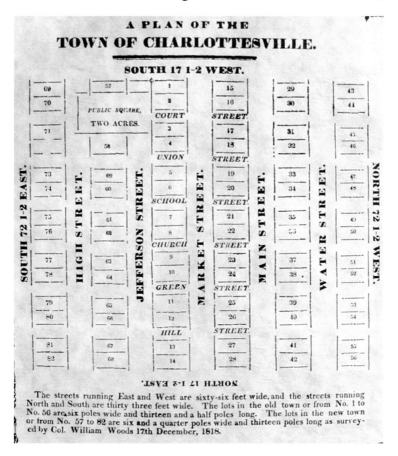

"A Plan of the Town of Charlottesville," surveyed by Colonel William Woods, December 17, 1818. *Albemarle Charlottesville Historical Society, Charlottesville, Virginia.*

horse and acted as a decoy for Tarleton's men, to give the legislators a chance to escape.

TARLETON'S ROUTE

17. LOUISA ROAD (ROUTE 33)

Go west on the Louisa Road (Route 33). After resting his men for three hours at Cuckoo's Tavern, Tarleton took this road on his way toward Charlottesville. Louisa County was created in 1742 from Hanover County. Patrick Henry represented the county in the House of Burgesses from 1765 to 1768, and lived at Roundabout Plantation during that time. By 1838, the Virginia Central Railroad had reached Louisa, and before 1860, the railroad extended to Gordonsville, and from there, to Charlottesville. Because the railroad was so important to the Confederate cause, there were several Union attempts to go

through Louisa to destroy the rail center at Gordonsville, including Stoneman's and Dahlgren's raids and the cavalry battle at Trevilians. For more information, see the website of the Louisa County Historical Society, http://louisacountyhistoricalsociety.org/lchs.htm.

18. BOSWELL'S TAVERN

At Trevilians, take Route 22 west to Boswell's Tavern. Tarleton and his men captured colonial troops and supply wagons near Boswell's Tavern during their march to Charlottesville on the night of June 3–4, 1781. A few days later, the forces of Lafayette and Wayne stopped at Boswell's on their march south to prevent Tarleton from getting to Scottsville. Boswell's Tavern is located on the edge of the Green Springs Historic Landmark District, just east of the intersection of Routes 22 and 15. It is a private residence and is not open to the public.

19. CASTLE HILL AND BELVOIR

Continue west on Route 22 to Cismont. Turn right onto Route 231. At this point Tarleton stopped at Castle Hill, the home of Dr. Thomas Walker and his son John Walker's Belvoir plantation, and took prisoner both Walkers and several legislators who were staying with them. Tarleton allowed his men to rest and eat while he and his officers requested breakfast from Mrs. Walker.

20. CIVIL WAR MUSEUM AT THE EXCHANGE HOTEL, GORDONSVILLE (400 SOUTH MAIN STREET)

http://www.hgiexchange.org/

A brief detour north on Route 231 will allow you to visit the Civil War Museum at the Exchange Hotel in Gordonsville. Built as a hotel just before the war, this building became the Gordonsville Receiving Hospital because of its site near the Virginia Central Railroad and the Alexandria Railroad. The hospital provided care for 70,000 Confederate and Union soldiers during the war. After 1865, the building was used as a Freedman's Bureau hospital. The hotel is considered one of the most haunted buildings in America.

21. SOUTHWEST MOUNTAINS HISTORIC RURAL DISTRICT

From Gordonsville, return south on Route 231/22. Between Route 231 and Route 20, south to I-64 and north to the Orange County line, is the Southwest Mountains Historic Rural District (NRHP, VLR). This is a 31,000-acre rural district that is famous for its historic farms, such as Castle Hill, Belmont, Cloverfields, Keswick and Edgehill. Enjoy the beautiful scenery of the area. Some notable sights are:

WALKER'S MILL. Located on the west side of Route 231, Walker's Mill is an eighteenth-century stone mill with a surviving miller's house. It is located south of Gordonsville on Happy Creek and is visible from the road.

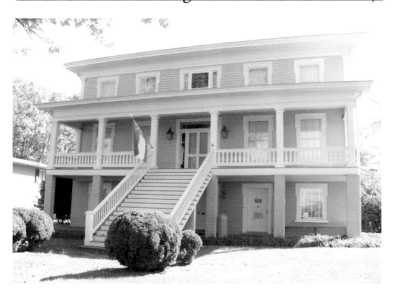

Civil War Museum at the Exchange Hotel, Gordonsville, Virginia, 2006.
Author's collection.

SITE OF THE CLASSICAL SCHOOL AT EDGEWORTH. Run by the Reverend James Maury, who was the second rector of the Fredericksville Parish from 1754 to 1768, this site is noted by a historical marker. Thomas Jefferson attended this school in his youth.

GRACE EPISCOPAL CHURCH (WALKER'S PARISH) http://www. gracekeswick.org/. This is one of three original churches of Fredericksville Parish and was established in 1747. The original building was a plastered and white-washed wood-frame building with a stone foundation, built on land donated by John Walker of Belvoir. Remnants of the stone foundation can be seen in the foundation at the front of the church. A stone church was built in 1855, but burned in 1895. The building standing today was completed in 1896.

22. JEFFERSON'S FARMS

Route 22 will merge with Route 250 going west. As you follow Route 250 west, you will pass Edgehill—the home of Thomas Mann Randolph Jr., the husband of Martha, Thomas Jefferson's daughter—and Shadwell, the farm built by Peter Jefferson. Edgehill was the site of a girls' school after the Civil War. The original house at Shadwell burned in 1770, but a second house was later built on the site. Later in the nineteenth century, the Shadwell site featured a manufacturing complex and mill on the Rivanna. Another former Jefferson farm, Lego, is located on the south side of Route 250 as you get closer to Charlottesville. Unfortunately, none of these houses are visible from the road, but the expanse of these properties gives one a sense of the scope of the Jefferson influence on the area.

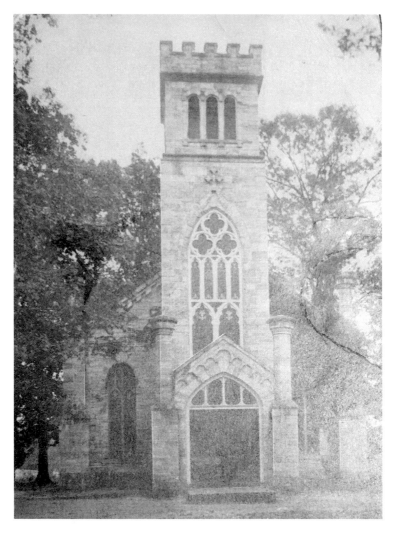

Grace Episcopal Church, Keswick, Virginia, circa 1913 (J.P. Bell, Lynchburg, Virginia). *Collection of J. Tracy Walker III, Charlottesville, Virginia.*

23. PANTOPS

A third Jefferson farm, Pantops, is located at the top of the mountain on the south side of the highway as you get closer to Charlottesville. Jefferson originally intended this property for his daughter Maria ("Polly"), but she died young, and Jefferson never followed through with his plans. The farm was sold in the early nineteenth century and was owned for many years by the Leitch-Anderson family, who built the first dwelling on the site. In 1877, the Reverend Edgar A. Woods established his famed Albemarle Academy on this site. The school was closed in 1906, and the buildings destroyed in a fire in the early twentieth century.

Pantops Farm after the Albemarle Academy additions. The original house built by James Leitch is the left-hand section of the building at the center of the photograph. *Milton Waff Collection, Albemarle Charlottesville Historical Society, Charlottesville, Virginia.*

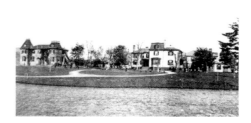

Going west on Route 250, turn left (south) onto Worrell Drive. The current house on the Pantops site is a large, white brick Colonial Revival mansion, built in 1937–38 by James Cheek of Richmond, and houses the KLUGE-RUHE ABORIGINAL ART COLLECTION (400 Worrell Drive, Charlottesville, 22911, http://www.virginia.edu/kluge-ruhe). This is the largest collection of Australian aboriginal artwork outside of Australia. Though the legendary view of the Blue Ridge at Pantops is somewhat difficult to see for all of the building going on, when you visit this free museum, you can walk around the grounds and see part of the view that Peter Jefferson saw when he first came to Albemarle County in 1734. Don't miss the startlingly realistic statuary scattered about the grounds.

24. FREE BRIDGE

Continue on Route 250 until you cross the Rivanna River at the Free Bridge, and then take an immediate left onto High Street. Following High Street, you will drive past Martha Jefferson Hospital and follow High Street as it makes a sharp right at the service station. Go three more blocks and you are at Court Square.

Before crossing the river, Tarleton sent Captain McLeod to Monticello to capture Governor Jefferson. In 1781, there were two places to cross the Rivanna near Charlottesville. One was the Secretary's Ford, near where the Woolen Mills is located now. At this point the Three Notch'd Road crossed the Rivanna and continued west to connect to Main Street. The other crossing was Moore's Ford/Lewis's Ferry (depending on how high the water was) near the current site of the Free Bridge. (This site is called the Free Bridge because there was no charge to cross it, unlike the other ferries and bridges crossing the Rivanna near Charlottesville.) There is no crossing at Secretary's Ford now, so you will use Free Bridge. A group of colonial militiamen attempted to stop Tarleton's troop at Secretary's Ford, but was easily defeated, and Tarleton's redcoats crossed the river and swept into Court Square.

TOUR—SIDE TRIPS

1. THE FARM (1201 EAST JEFFERSON STREET)

As you come to the intersection of High and Tenth Streets (across from Martha Jefferson Hospital), take a left onto Tenth and another left onto East Jefferson Street, and follow East Jefferson two blocks to the Farm, the home of Nicholas Lewis and his wife, Mary Walker Lewis. (Mrs. Lewis was the daughter of Thomas Walker of Castle Hill.) Tarleton and his officers stayed here over the night of June 4–5, while the British soldiers camped on the three blocks west of Park Street and north of High Street. The American prisoners they had taken were locked in a coal cellar on the Farm. When they left Charlottesville, the British soldiers took all the food and livestock they could carry, including Mrs. Lewis's flock of ducks—all except for the drake. The story goes that Mrs. Lewis sent a slave to give the drake to Tarleton, saying that since he'd taken her flock, he might as well take the drake too, whereupon Tarleton took the bird and sent the servant back with his thanks.

The current main house on the property dates from about 1826, and was built by John A.G. Davis, a professor at the university. The only colonial building to survive on the property is a brick building that originally served as a kitchen. The interior features a large cooking fireplace with a flanking bread oven. In the nineteenth century, the building was enlarged to include a second story. During the Civil War, this property was owned by Thomas Farish. It was used by General George A. Custer as his headquarters during the Union occupation of Charlottesville. (NRHP, VLR)

2. RIVANNA TRAILS

http://avenue.org/rivanna/home.html

The Rivanna Trails Foundation has created and maintains almost twenty miles of footpaths and hiking trails around the city of Charlottesville and on the banks of the Rivanna River. You can download a PDF copy of the trail map and trail descriptions from the foundation's website. The mile-and-a-half section of the trail from Quarry Park to Woolen Mills passes the location of Secretary's Ford over the Rivanna at Moore's Creek, the site of the old railroad bridge to the mills and the Woolen Mills buildings themselves. Please note that this section of the trail is rated "difficult" and is not handicap accessible.

3. SILVER THATCH INN (3001 HOLLYMEAD DRIVE)

http://www.silverthatch.com/

This inn is located in the Hollymead subdivision just north of Charlottesville on Route 29. The inn contains one of the oldest buildings in central Virginia. The oldest section is a two-story log cabin built in 1780 by Hessian soldiers while they were prisoners in

A cabin built by soldiers of the Convention Army, circa 1780, now part of the Silver Thatch Inn, 2007. *Author's collection.*

Charlottesville. In 1812, the center section of the inn was added, and it became a boys' school. After that, the farm became part of a tobacco plantation and a melon farm during and after the Civil War. B.F.D. Runk, who was a University of Virginia dean for thirty years, added another wing in 1937 and an outside cottage in 1984. The complex of buildings is now a bed-and-breakfast inn and restaurant.

4. THE BARRACKS (BARRACKS FARM ROAD)

By tradition, Barracks Farm was the location of the Convention Army barracks from 1779 to 1781. This has been verified by archaeological work on the property, though there is no obvious visual evidence of the site. Barracks Farm is a private residence, but the Albemarle

County Historical Society has placed a plaque at the site of the former cemetery in which a number of soldiers from the Convention Army lie buried. The site itself is on private property, but the plaque is located on Ivy Farm Road near its intersection with Stillhouse Road.

READ MORE ABOUT IT

Clary, David A. *Adopted Son: Washington, Lafayette, and the Friendship that Saved the Revolution.* New York: Bantam Books, 2007.

Ellis, Joseph J. *Founding Brothers: The Revolutionary Generation.* New York: Alfred A. Knopf, 2000.

Ketcham, Richard M. *Victory at Yorktown: The Campaign that Won the Revolution.* New York: Henry Holt, 2004.

Lancaster, Bruce. *The American Revolution.* New York: Mariner Books, 2001, c1971.

Sampson, Richard. *Escape in America: The British Convention Prisoners, 1777–1783.* Chippenham, Wiltshire: Picton Pub., 1995.

Chapter 4

The New American Republic in Central Virginia (1783–1860)

The federal census of 1790 reported that the population of Albemarle County was 12,585 people—54 percent white and 46 percent black, including 171 free people of color. In that year, Charlottesville, the county seat, was made up of forty-five houses, a tavern, a courthouse and a jail. Throughout the antebellum period the county, like the rest of the new country, grew and prospered through agriculture and the ingenuity of its people.

In forty years, according to the 1830 census, the county's population had grown to 22,618—10,455 white and 12,163 black, including 373 free people of color. By 1835, Charlottesville itself had blossomed, with a population of 957—550 whites, 348 enslaved blacks and 59 free blacks—and contained about 200 houses, 4 churches, 3 hotels, 2 bookstores, a tavern, 20 general merchants' stores and a wide variety of artisans' businesses, including tailors, hatters, tanners, saddlers, cabinetmakers, wheelwrights, jewelers and confectioners. In addition, the town was home to six attorneys, six physicians, three surgeon dentists and two druggists' shops. The town had three newspapers, a circulating library and a fire engine. Several lines of the stagecoach passed through daily. Nearby, there were several mills, including the Woolen Mills at Pireus on the Rivanna near Secretary's Ford; the sawmill, flour mill and the carding factory downriver at Shadwell; and the Hydraulic and Rio Mills northwest of the town.[46]

Charlottesville's prosperity came mainly from agriculture. At the beginning of the period, the county was dominated by large plantations, and tobacco was still the main cash crop. Most of the planters were interested in improving their farms and livestock, and in 1817, the Albemarle Agricultural Society was formed. Ex-President James Madison, though living in Orange County, was the first president of this organization, and soon-to-be-Governor Thomas Mann Randolph Jr. was the first vice-president. Beginning in 1825, as part of a growing movement across the United States, the society sponsored an annual agricultural fair to display new farming techniques, equipment and

livestock to county farmers. These county agricultural fairs lasted until the 1840s, when the society disbanded, and its function was taken over by the state society and state fairs.[47] By the 1860s, tobacco had given way to wheat and similar crops.

Slavery

As in the rest of Virginia and the South, slave labor was the foundation of Albemarle County's agricultural prosperity and growing industrial success. In the years after the Revolution, many white Southerners questioned the long-term social stability—not to mention the morality—of a society based on the enslavement of others, but few owners of slaves acted upon those feelings. Slaves were an extremely valuable commodity in the antebellum South. Even the country's founding fathers failed to live up to the strength of their convictions on this issue. In spite of his strong feelings about slavery, Thomas Jefferson allowed only four slaves to "escape" during his lifetime and freed only five in his will. James Madison never freed his slaves, though he had discussed such a plan with his secretary, Edward Coles.

This same Edward Coles of Enniscorthy was the first man from Albemarle to free all of his slaves during his lifetime. In 1819, Coles moved with his twenty inherited slaves to Edwardsville, Illinois, where he set them up as free men on their own farms. Coles himself eventually became governor of Illinois, where he led a successful campaign to prevent slavery from ever becoming legal in that state. Several individuals from Albemarle freed their slaves in their wills, among them Dr. Charles D. Everett of Belmont, who provided for the settlement of his slaves in Pennsylvania, and John Terrell, who directed his heir to send his slaves to Liberia upon his death.

The Albemarle Auxiliary Colonization Society was a branch of a national organization with the goal of returning freed blacks to Liberia.[48] The group was active in the first half of the nineteenth century. But in Albemarle, there seemed to be no solution to the dilemma between financial dependence and moral behavior. The numbers of slaves and slave owners grew, until by 1860, out of a population of 26,625, 12,103 were white and 14,522 black (among those were 606 free blacks). Most strikingly, as John Hammond Moore points out in his book *Albemarle: Jefferson's County, 1727–1976*, the percentage of county residents owning slaves grew from 61 percent in 1820 to 78 percent in 1860.[49]

Jefferson expressed the conflict well when he wrote in 1820 regarding the Missouri question and slavery, "But as it is, we have the wolf by the ears, and we can neither hold him, nor safely let him go. Justice is in one scale, and self-preservation in the other."[50]

THE RIVER

It is hard to overestimate the importance of the James and Rivanna Rivers in the growth of Albemarle County. Overland shipping was too expensive and time-consuming, so most of the commerce was conducted by water. Tobacco, flour and other produce were shipped downstream, and luxuries such as coffee, salt, molasses and whiskey returned upstream.

In the middle of the eighteenth century, the Reverend Robert Rose, the first minister of St. Anne's Parish in southern Albemarle, came up with the idea of connecting two canoes side by side. These double canoes could carry up to two thousand pounds, or eight hogsheads of tobacco. In 1774, an Amherst County farmer named Anthony Rucker is said to have invented the first batteau, a flat-bottomed boat that replaced the double canoe and was used to ship goods on the James and Rivanna Rivers in the eighteenth and nineteenth centuries. The batteaux were fifty to sixty feet long and could carry eleven hogsheads of tobacco with a one-foot draft, allowing shipping into the shallower stretches of the rivers. Thomas Jefferson attended the launching of the first batteaux and gave them their name.

Navigation of the Rivanna has always been a concern of the inhabitants of central Virginia. In 1763, Thomas Jefferson was one of a group of landowners who subscribed £200 to make improvements to the Rivanna. The river was surveyed, and the water channel dredged and trees and large rocks removed. In 1805, the Rivanna Navigation Company was organized to improve the navigability of the Rivanna River. By 1817, the company was working on straightening and deepening sluices (narrow channels) and building wing-dams at more than twenty-seven falls, shoals and fords between Milton and Columbia. These dams were placed to direct the river into the sluices, making a deeper channel for the batteaux to navigate.[51]

The town of Milton was established in 1790 at the Shallows of the Rivanna as a shipping town where batteaux deposited their cargoes for trans-shipping by horse and wagon to the surrounding towns. The river could be crossed here by way of McGehee's Ford, named after a local landowner, and in 1794, John Oglesby started a free ferry. By 1812, the Rivanna was navigable (when there was enough water) up to Pireus, about a mile and a half south of Charlottesville, where Moore's Creek met the Rivanna. In 1815, the village had about twenty-five houses, a post office, a tobacco inspection warehouse, a tobacco display and a grain display. However, Milton's period of importance was brief, beginning its decline before 1820. Several of the buildings in Milton were moved to other locations, and at least two of those were re-erected in Charlottesville. By 1835, Milton had virtually disappeared.

Scott's Landing, though no longer the county seat, continued to be prosperous. The town was incorporated as Scottsville in 1818. By

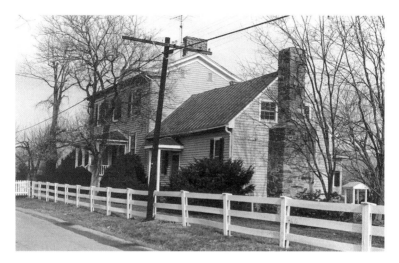

Tavern at Milton, Virginia, date unknown. This structure is one of the two early nineteenth-century buildings left in Milton. *Milton Waff Collection, Albemarle Charlottesville Historical Society, Charlottesville, Virginia.*

1835, Scottsville had a population of 600, which had grown to 666 by 1850. In 1840, the completion of the James and Kanawha Canal that paralleled the James for 147 miles from Richmond to Lynchburg, and the several fords and ferries available at that site, made the 1840s and 1850s the "Golden Age" of Scottsville. Nine freight boats and two packet boats moved east down the canal every day during this period.

In 1817, Scottsville became the eastern terminus for the Staunton and James River Turnpike (the "Valley Road"), the first turnpike in the United States. It took six years to build and had five tollgates. Later in its history, sections of the turnpike were planked, and the route exists today with the name Plank Road.[52] In his memoirs, William White wrote, "A hundred large Valley wagons have been seen unloading their rich freight of flour, bacon, venison, hams, butter, cheese, beeswax, etc., in one day; and this when the population [of Scottsville] did not exceed five hundred persons of all ages and conditions."[53] Until the railroad was built in Albemarle County in the 1850s, this road was the major route for goods shipped between southern Albemarle and the Shenandoah Valley.

THE UNIVERSITY OF VIRGINIA

Thomas Jefferson had not remained idle after his term as governor of Virginia. He was elected to Congress, served as the U.S. ambassador to France and in 1800 was elected president of the United States, an office in which he served two terms. Under Jefferson's administration, the United States acquired the Louisiana Territory from Napoleon Bonaparte's government, doubling the size of the country. In 1803,

Jefferson authorized an expedition to explore the new territory, carried out by Meriwether Lewis, an Albemarle native and Jefferson's private secretary, and William Clark, younger brother of George Rogers Clark, who had been born in Albemarle but raised in Kentucky.

For many years, Thomas Jefferson had promoted the creation of a public college in central Virginia; he called it "the project of my old age." By 1810, an academy was mentioned in the description of Charlottesville in Morse's *Gazetteer*. Although it existed only on paper, this Albemarle Academy was the foundation for Central College, now the University of Virginia.

In 1817, the cornerstone for Central College was laid, and in 1819 the state legislature chartered the institution. Jefferson wrote,

> *We have purchased a site of 200 acres, one mile above Charlottesville, it is not proposed to erect one large building, which would exhaust our funds at once; but on each side of a lawn 200 feet wide, we shall erect separate pavilions, 220 feet apart, for each professor, & his school, two story high, filling up the space between with a range of small chambers or dormitories, of one story, for the students; the whole connected by a covered colonnade in front. The pavilions, besides the lecturing room, will have two or four rooms for the accommodation of the professor, according to his family, with necessary offices, garden etc.*[54]

In Jefferson's notes, he describes the classical models for the university pavilions, which were intended as a living classroom in the classics and architecture. The Rotunda was to replicate the "Corinthian of the Pantheon" by Palladio. The ten pavilions included Doric, Ionic and Corinthian designs from Palladio and Chambray.

The first class at the University of Virginia opened on March 7, 1825, with 123 students, though the buildings were not all complete. The Rotunda, begun in 1822, was not finished until 1832, when stone steps were installed.

LAFAYETTE'S TOUR OF AMERICA

After returning to France in 1782 to a hero's welcome, the Marquis de Lafayette had never revisited the United States. In 1824, at age sixty-six, the aging hero responded to an invitation by the U.S. Congress to visit the country he had helped to create. So in August, Lafayette arrived in New York intending to spend only three months visiting old friends, since that was the most he could afford. To his amazement, the people of the United States welcomed him with fervor; his planned three-month visit expanded to fourteen months, and the bill for the tour was paid for by the people of a grateful nation. During that period, accompanied by his son, George Washington de Lafayette, the Marquis managed to visit every former colony and was honored in every community he passed through.

After visiting President James Monroe in Washington, D.C., Lafayette traveled to Virginia, where he first stopped at Yorktown, the site of the American and French victory over the British. Heading west to Monticello, the group stopped for two days to rest in Richmond, then continued west through Fluvanna County, where the group was fêted and fed. The next day, the party continued toward Charlottesville and was met at the Albemarle/Fluvanna County line by a troop of cavalry named the Lafayette Guards in the Marquis's honor. The guards escorted them to Boyd's Tavern, where Lafayette and his party ate luncheon and bade farewell to the officials of Fluvanna County. Continuing west on the Three Notch'd Road, Lafayette and his escort finally arrived at Monticello, the home of his good friend, Thomas Jefferson, whom he had not seen for nearly forty years.

The lawn on the eastern side of the house at Monticello contains not quite an acre. On this spot was the meeting of Jefferson and Lafayette, on the latter's visit to the United States. The barouche containing Lafayette stopped at the edge of this lawn. His escort—one hundred and twenty mounted men—formed on one side in a semicircle extending from the carriage to the house. A crowd of about two hundred men, who were drawn together by curiosity to witness the meeting of these two venerable men, formed themselves in a semicircle on the opposite side. As Lafayette descended from the carriage, Jefferson descended the steps of the portico. The scene which followed was touching. Jefferson was feeble and tottering with age—Lafayette permanently lamed and broken in health by his long confinement in the dungeon of Olmutz. As they approached each other, their uncertain gait quickened itself into a shuffling run, and exclaiming, "Ah, Jefferson!" "Ah, Lafayette!" they burst into tears as they fell into each other's arms. Among the four hundred men witnessing the scene there was not a dry eye—no sound save an occasional suppressed sob. The two old men entered the house as the crowd dispersed in profound silence.[55]

The next day, November 5, Lafayette was honored by a formal dinner that was held at the not-yet-opened University of Virginia.

The first great public dinner that took place at the University occurred before all its buildings were completed and even before a single student had matriculated; this was given in honor of Lafayette's visit in 1824…The distinguished Frenchman arrived in Albemarle on November 4, about four months before the [University] lectures began…On the [5th], Jefferson, Lafayette, and Madison[56] set out from Monticello in a landau for Charlottesville, with a numerous escort of cavalrymen and citizens on horseback. A reception was held in the town [at the Central Hotel], and then the procession started for the University; and only came to a halt when it reached the foot of the Lawn. On the verdant terraces, rising one above the other, had gathered groups of gayly dressed ladies, who waved their handkerchiefs when the French hero appeared, and then rushed forward and formed a lane, along

East front and lawn of Monticello, Charlottesville, Virginia, 2006. *Author's collection.*

which he and his companions, with many polite bows, passed from their carriage to the Rotunda steps. William F. Gordon [Albemarle County representative to the state general assembly] *there received them with an eloquent address of welcome. A short interval of rest ensued, and then Lafayette, with Jefferson and Madison on either side, returned to the Lawn, and, with kindly urbanity, mingled with the assembled people.*

The dinner was held in the great circular room of the [still unfinished] *Rotunda, and there could not have been found in America another apartment more imposing for the purpose. The hour chosen was three o'clock in the afternoon.* [Four hundred people attended, and the] *tables were arranged in* [three] *concentric circles, with a laurel bower above Lafayette's seat. That day…was characterized by unbroken dignity and orderliness, universal enthusiasm, and profound emotion.*[57]

The contemporary reports tell us that Lafayette's toast to Jefferson at that dinner so touched the great man that he was unable to speak, and he handed Valentine W. Southall, the presiding official, his written remarks, which that gentleman read in reply. Jefferson said of Lafayette, "He made our cause his own, as in truth it was that of his native country also…In truth, I only held the nail, he drove it. Honor him, then, as your benefactor in peace as well as in war."[58]

On November 19, after two weeks of dinners and visiting, Lafayette and party left Monticello to visit James and Dolley Madison at Montpelier, thirty miles north. The group headed toward Thornton's Tavern in Gordonsville, where the Orange County reception was to take place.

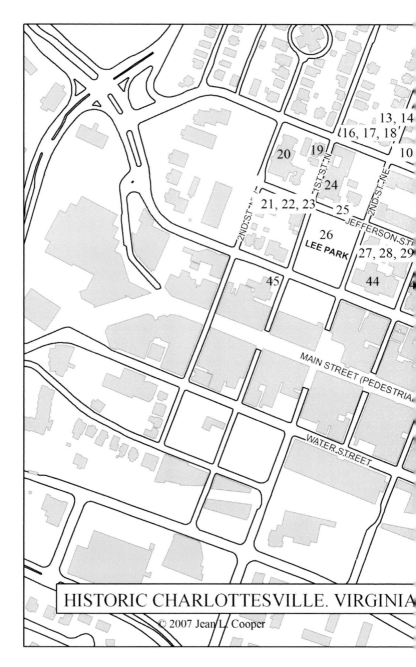

Map of Charlottesville, original town tour, 2007. *Author's collection.*

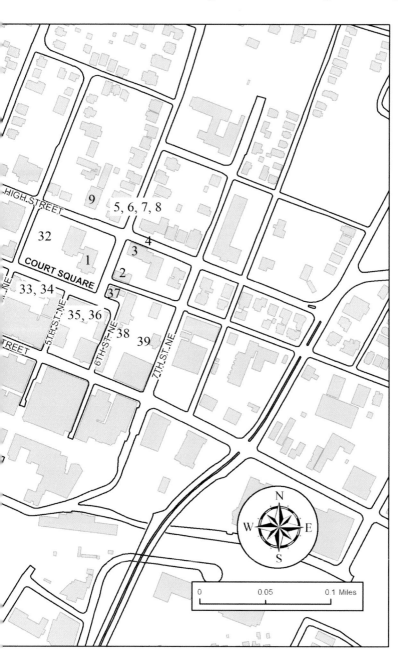

During the whole passage to that place from Monticello, the inhabitants from either side of the road, notwithstanding the inclemency of the weather, crowded the highway, manifesting the same interest, the same enthusiasm, the same veneration and affection, which have everywhere been felt on the approach of this illustrious benefactor of man…Ever and anon, were discernable from the neighboring farm-houses, the fair daughters of the mountains, waving their white 'kerchiefs in attestation of the same feelings which pervaded the animated groups of their fathers, husbands, and brothers, who had assembled on the borders of the highway.[59]

In August 1825, before he returned to France, Lafayette returned to Monticello for another visit with Jefferson, who was very ill. Lafayette "found him on a couch in the drawing-room, evidently altered since he saw him the year before, and then suffering acute pain." On that visit, Lafayette again was honored at a public dinner at the university given by the professors and students, and "though Mr. Jefferson could not partake of the entertainment, it afforded him no small gratification."[60]

Tour—Charlottesville, Original Town

The Charlottesville Historic District (NRHP, VLR) contains eighty-eight buildings and two districts that are examples of many different styles of architecture, ranging from the Federal and Georgian styles of the late eighteenth century through the Art Deco and Jeffersonian Revival styles of the early twentieth century. Many of the buildings are privately owned homes and are not open to the public unless otherwise indicated. The original town site is relatively flat, with paved sidewalks, and is accessible for those with mobility issues.

1. Albemarle County Courthouse (501 East Jefferson Street, Court Square)
The original wooden courthouse (built in 1762 on the model of the Henrico County Courthouse) was replaced in 1803 by a brick structure that is the north wing of the present courthouse. Thomas Jefferson, James Monroe and James Madison were all lawyers, and met often at the courthouse where Jefferson and Monroe sat as magistrates of the county. Madison was the first president of the Albemarle Agricultural Society and was a member of the University of Virginia's first Board of Visitors (the governing body of the university). In addition, Charlottesville did not have any church buildings until 1826, so the brick courthouse served as the place of worship for the Episcopalians, Presbyterians, Methodists and Baptists, each offering services one Sunday a month. Jefferson was a frequent worshipper, riding down from Monticello and bringing his cane that unfolded into a chair, an invention of his own.

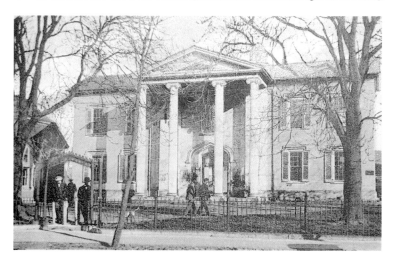

Albemarle County Courthouse, Charlottesville, Virginia, circa 1920 (American News Co.). *Collection of J. Tracy Walker III, Charlottesville, Virginia.*

Builder George Spooner was commissioned to build a new portico for the building in 1859. The resulting façade with flanking towers crowned with gables was generally considered an architectural "monstrosity," and Spooner was ordered to tear it down and start again. In 1867, the south wing and a simple portico were added. The courthouse was renovated in 1938 and again in 1964.

2. Swan Tavern (300 Park Street)
In 1773, John Jouett Sr. (father of the Revolutionary hero) purchased one hundred acres adjoining the original town of Charlottesville on the north and east. The Swan Tavern was built next to the Battery, now the corner of Park and East Jefferson Streets, about that year. When the legislature was moved to Charlottesville from May 24 to June 4, 1781, the Swan was apparently used by the legislature in some capacity, because Jouett later sent a request to the general assembly to compensate him for repairs to the doors for the use of the legislature. (There's no mention that Jouett ever received compensation for his expenses, though.) In 1790, Jouett laid out Maiden Lane (also called North Street, now called High Street) on part of the property he had purchased, with lots for sale on either side of the street.

Jouett was the proprietor of the Swan until his death in 1802. There being no public cemetery in Charlottesville at that time, there is a local legend that Jouett was buried in the yard at the rear of the tavern. In his recollections, James Alexander says, "There is a cluster of old boxwood at the rear of the Matacia home, 610 East High Street, which is believed to mark the site of the grave."[61] There is no record of Jouett's grave having been moved, so it is possible that his body still lies behind the site of his tavern.

Another Alexander remembrance also involved the Swan. "In 1808, a man by the name of John (Jack) McCoy was barkeeper in the Swan. He was murdered and thrown into the well on the premises. The landlord, who was absent on the night that the murder occurred, was accused of being concerned in it, but he was acquitted…No clue as to who committed the murder was ever afterwards obtained."[62]

The Swan changed hands several times after 1808, but continued in business for more than twenty years after this event. In the summer of 1832, the old Swan Tavern building tumbled down (or was pulled down). At the time of its fall, a ball at the Eagle Hotel was in progress; the noise of the crash startled the dancing guests and caused them to think it was an earthquake. The current townhouse on the site replaced the old tavern about 1832 and was the home of the Samuel Leitch Jr. family for many years. It now belongs to the Red Land Club, a private club with membership restricted to male attorneys.

3. OLD TOWN HALL / LEVY OPERA HOUSE (350 PARK STREET)

Built in 1852, the town hall provided a venue for cultural performances. The year after it opened, the town hall hosted a performance by the famous Adelina Patti. Performances ceased with the onset of the Civil War, and the building was used to house wounded soldiers. After the war, the town hall was renovated as a modern opera house in 1888 by Jefferson Levy, the owner of Monticello and one of Charlottesville's cultural benefactors. The new performance hall had a twenty-eight- by forty-eight-foot stage, with an orchestra pit in front and dressing rooms for the performers underneath, and could accommodate an audience of five hundred in graduated seating and a gallery. The heyday of the opera house as a performing hall was 1886 to 1896. From 1900 to 1911, it served as the Jefferson School for Boys. Levy sold it in 1914, and for a time thereafter the building was used as apartments. It currently houses the Charlottesville Family Court.

4. THE BATTERY

On the original town diagram, the space to the north of the town hall was labeled "the Battery" and was used for military drills and games. Now it is part of East High Street.

5. ERNEST PUGH HOUSE (401 PARK STREET)

This Colonial Revival house was built in 1924. In 1946, it served as an annex for the Monticello Hotel.

6. THE TOWER HOUSE (408 PARK STREET)

This two-story brick house is in the Italianate style, and was built sometime between 1854 and 1861. The most notable feature of this style is the tower and the double circular-headed windows on the third level of the tower. It is known to have been standing during the Civil

War, and it is one of three houses that claim to have served as General Sheridan's headquarters in March 1865.

7. WATSON-WOOD HOUSE (415 PARK STREET)

William Watson, the town jailer, purchased this lot in 1813, and probably built the house soon after. The original building was a T-shaped, two-story brick house with a wide central hall. The original house had Federal mantels, several of which have survived. Thomas Wood bought the house in 1858. At some point before 1911, the exterior of the house was totally renovated into a Victorian stucco with matching towers, leaving no evidence of the original construction.

8. SAUNDERS-WILSON HOUSE (416 PARK STREET)

The earliest evidence for this house is in 1824, as it was occupied in that year by Francis Bowman, the pastor of the Presbyterian church. The original Federal-style building is the northern section of the current house, with a three-bay, two-room-deep, side-hall plan with two interior chimneys. The Victorian southern section is of later construction, probably sometime between 1850 and 1881, and includes a bay window, overhanging eaves and a bracketed cornice and double gallery on the front of the house.

Go back to High Street and turn west.

9. ALBEMARLE COUNTY JAIL (409 EAST HIGH STREET)

This complex contains both the jailer's house (built about 1870) and the jail (built in 1875). In February 1905, J. Samuel McCue, a former mayor of Charlottesville, was executed here for the murder of his wife, Fannie. It was the last legal hanging in the state.[63] The jail has three-foot-thick walls pierced with small splayed windows covered with thick iron bars. The seven cells were originally floored in stone, but are now covered with cement.

10. TRICE-TOWE HOUSE (211 EAST HIGH STREET)

Built about 1850, this is a late Georgian detached house. It has two stories on a high basement and is similar to the Leitch-Munday house (see number 16). The house was stuccoed in 1919. S.S. Van Dyne (whose real name was Willard Huntington Wright), a nationally known mystery writer, lived in this house.

11. NELSON HOUSE (205 EAST HIGH STREET)

This house was built between 1857 and 1862 in an Italianate style. It is three stories tall, built on a high basement. The veranda has octagonal columns and brackets. Exterior stairs are placed to the side.

12. MINOR-NELSON HOUSE (201 EAST HIGH STREET)

Built between 1830 and 1840 in the Neoclassical style, the original section is five bays wide and two stories tall. In the second half of the

nineteenth century, a central gable and overhanging eaves were added. The western wing and verandas were added by Dr. Hugh T. Nelson about 1895. The interior still has three early Jeffersonian mantels.

Turn north on Second Street to see the following three houses, then return to High Street.

13. ROBINSON HOUSE (410 SECOND STREET NORTHEAST)
This house is a two-story frame house in the Victorian vernacular style, built in 1896.

14. THE OLD MANSE (422 SECOND STREET NORTHEAST)
The Old Manse was built in 1839 in the late Federal style. It is two stories high and five bays wide with an entrance porch of coupled octagonal columns. The side porch was added in the 1930s. This was the site of the Charlottesville Female Academy, chartered in 1839, run by the Reverend William S. White. The house has served as the "manse" for both the Baptist church and the Presbyterian church.

15. LIPOP HOUSE (426 SECOND STREET NORTHEAST)
Built about 1836 in the Federal style, this house has a two-story central hall plan with interior chimneys. The squared-column porch on the front is a late nineteenth-century addition. It was owned by the Railey family from 1836 to 1851 and purchased by Joseph W. Lipop in 1865.

16. LEITCH-MUNDAY HOUSE (115 EAST HIGH STREET)
This house is a two-story, five-bay brick house with a central hall plan. Though its Federal style indicates a date in the late 1820s, the deed indicates it was built in the late 1840s. The house was the home of Dr. James A. Leitch; Leitch's widow lived here until 1908. In 1938, the house was purchased by the Munday family.

17. GEORGE HOUSE (105 EAST HIGH STREET)
This two-story brick house is in the Victorian vernacular style, built about 1872. Originally the house had a veranda, which was removed in 1968 and replaced with the double curved steps.

18. THE PERKINS HOUSE (433 NORTH FIRST STREET)
This house, built before 1863, is in a Gothic Revival style. It has one and a half stories above a high basement, with pointed windows and sawn bargeboards and pendants. The veranda is not original, nor is the stucco.

19. CARVER HOUSE (100 WEST HIGH STREET)
Built about 1886 to 1889 in the Victorian style, this house has a central hall and a projecting end pavilion. The house was used by Dr. E.M. Magruder as a residence before he built his sanitarium at 100 West Jefferson Street.

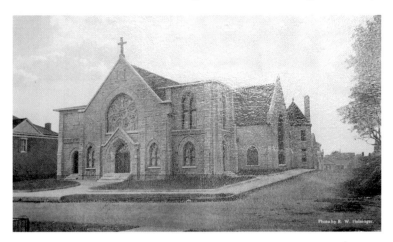

Christ Episcopal Church, Charlottesville, Virginia, circa 1905–08 (W.T. Walp). *Collection of J. Tracy Walker III, Charlottesville, Virginia.*

20. CHRIST EPISCOPAL CHURCH (120 WEST HIGH STREET)
This Episcopal congregation was organized in 1820. The first building on this site, built in 1826, was designed in the Neoclassical style by Thomas Jefferson. In 1895, that building was demolished, and a new church in the late Gothic Revival style was built between 1895 and 1898. The building is made of coursed, rusticated granite blocks quarried in Richmond. The large rose window, flat buttresses, entrance portal and two square towers are indicative of the Gothic style. Some of the stained-glass windows were purchased from the studio of L.C. Tiffany.

Turn south on Second Street Northwest and walk one block to Jefferson Street. Proceed from west to east on this street.

21. REVERCOMB HOUSE (116 WEST JEFFERSON STREET)
This Colonial Revival–style house was built in 1913.

22. JONES HOUSE (106 WEST JEFFERSON STREET)
This house was built about 1899 in the Victorian vernacular style.

23. MAGRUDER SANITARIUM (100 WEST JEFFERSON STREET)
Until late in the nineteenth century, most people were cared for in their homes when they were ill. After the Civil War, Charlottesville's only hospital was the Piedmont Colored Hospital, established near the Gas House. Dr. Edward May Magruder built this two-and-a-half-story Victorian in 1899 as a private sanitarium for his own patients. After the University of Virginia Hospital opened in 1901 and Martha Jefferson Hospital opened in 1904, Dr. Magruder made this building his residence and offices. The building is notable for its segmented, arched windows and the porches on the front and back, which allowed

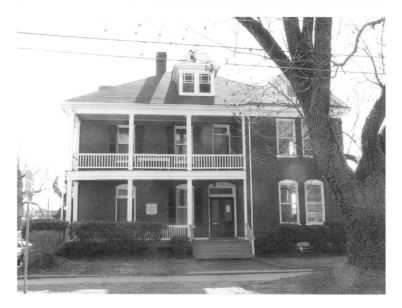

Magruder Sanitarium (100 West Jefferson Street), 2007. *Author's collection.*

patients fresh air during convalescence. One of Dr. Magruder's daughters, Evelina, was the first female graduate of the University of Virginia School of Architecture in 1935.

24. First Methodist Church (101 East Jefferson Street)
The original Methodist church in Charlottesville was built in 1834 on the south side of Water Street, between First and West Second Streets. A replacement building was started on a lot across from the original in 1859 and construction continued on the new church for some fifty years. In 1923 and 1924, the congregation built a third church on East Jefferson Street. It was designed by architect Joseph Hudnut with a monumental Colonial Revival portico with four Doric columns, an entablature with triglyphs and a broad pediment. The striking detached tower and steeple are also notable.

25. Social Hall/John R. Jones House (109 East Jefferson Street)
This was the home of John R. Jones, built in 1814. Jones was a financial agent for several important planters in the county, and lived on this property until 1857. The house is in the late Georgian style with a formal symmetrical composition, two stories high and five bays wide and has a low roof. It has a Federal fanlight doorway and blind windows to make the symmetry complete. The veranda is a later Colonial Revival addition.

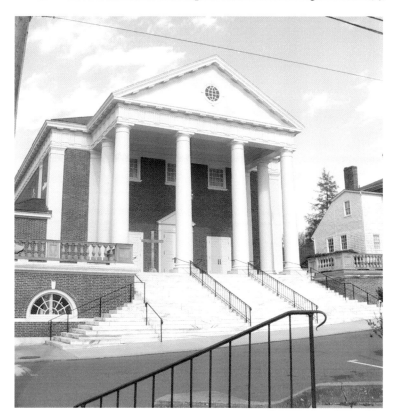

First Methodist Church (101 East Jefferson Street), 2007. *Author's collection.*

26. STATUE OF ROBERT EDWARD LEE IN LEE PARK (100 BLOCK, EAST JEFFERSON STREET)

On the south side of this block is Lee Park. This sculpture was created by Henry Shrady and Leo Lentelli, and depicts General Lee on his horse, Traveller. The pink granite pedestal was designed by architect Walter Blair. Philanthropist Paul Goodloe McIntire sited the statue in Lee Park, and gave the park and statue to the city on May 21, 1924.

27. MCINTIRE PUBLIC LIBRARY (200 SECOND STREET NORTHEAST)

Originally the home of Charlottesville's public library, this building now houses the Albemarle Charlottesville Historical Society. Donated by philanthropist Paul Goodloe McIntire, this is a Neoclassical brick building with a half-moon portico with marble steps and columns, built between 1919 and 1922.

Paul Goodloe McIntire was born in Charlottesville in 1860. His father, George Malcolm McIntire, served as a mayor of the town during the Civil War. His mother, Catherine Clark McIntire, belonged to the local Clark family that had produced George Rogers Clark and William Clark (of Lewis and Clark fame). McIntire made his fortune

Above: Statue of Robert Edward Lee that was erected in 1924. *Author's collection.*

Opposite above: McIntire Public Library, now the location of the Albemarle Charlottesville Historical Society, 2006. *Author's collection.*

Opposite below: Holy Comforter Catholic Church, Charlottesville, Virginia, 2007. *Author's collection.*

as a stockbroker, first on the Chicago Stock Exchange and then on the New York Stock Exchange. When he retired to Charlottesville in 1919, McIntire funded various civic projects, such as the building of this city library, four city parks and four outdoor sculptures. Other philanthropic projects included funding art purchases for the local schools and the University of Virginia and building projects such as the university's McIntire School of Commerce and the Greek Amphitheater.

28. GOLDSMITH-BISHOP HOUSE (206 EAST JEFFERSON STREET)

This house was built in the late nineteenth century by Marx Goldsmith, and sold to Mrs. Carlisle Bishop in 1919. It is a simple two-bay Colonial Revival frame house, with a heavy Victorian staircase and a central chimney, and it still contains the original doors and mantels.

29. HOLY COMFORTER CATHOLIC CHURCH (210 EAST JEFFERSON STREET)

Built in 1925, this brick Roman Revival church was designed in 1925 by Stanislaw Makielski, based on Leo Battista Alberti's design for the church of San Andrea in Mantua, Italy. The front face is modeled as a triumphal arch, with pilasters, a recessed, pedimented entrance set against a thermal window and a gabled pediment.

30. BETH ISRAEL TEMPLE (301 EAST JEFFERSON STREET)

The Beth Israel congregation dates to 1863. This late Gothic Revival synagogue was situated between 1882 and 1903 in the 200 block of Market Street. In 1904, this structure was moved to its present location, and a new federal post office built on its previous site. The building's most prominent architectural feature is the façade, with the five low pinnacles supported by corbels and square piers, an entrance door set into a splayed reveal under a pointed arch and tall lance windows, containing the mostly original art glass.

31. WOOD-ROSSER HOUSE (304 EAST JEFFERSON STREET) AND WOOD-KAUFMAN HOUSE (306 EAST JEFFERSON STREET)

Built in 1904, these houses were originally in the Queen Anne style, but have been remodeled to look like Colonial Revival buildings.

32. STATUE OF THOMAS JONATHAN JACKSON IN JACKSON PARK (400 BLOCK, EAST JEFFERSON STREET)

Until the 1920s, this was the McKee block, containing a group of mercantile townhouses that were purchased by Paul Goodloe McIntire and razed to make room for the park. It was created by Charles Keck and presented to the city on October 19, 1921. The statue depicts Stonewall Jackson on his horse, Little Sorrel, riding into battle. On the pink granite pedestal, the figures of Faith and Valor are carved in high relief.

33. BUTLER-NORRIS HOUSE (410 EAST JEFFERSON STREET)

http://www.innatcourtsquare.com/

This house is the only example of eighteenth-century architecture left in the Court Square area. Edward Butler, a signer of the Albemarle Declaration of Independence, built this house about 1785. It is a two-story, three-bay vernacular brick building with the only molded brick cornice in the city. In 1808, Butler sold the property to John Kelly, who eventually gave the house and land to his son-in-law, Opie Norris. It is now a bed-and-breakfast inn called the Inn at Court Square.

Beth Israel Synagogue, Charlottesville, Virginia, 2007. *Author's collection.*

34. NORRIS-McCUE HOUSE (412 EAST JEFFERSON STREET)

This Federal-style row house was built between 1825 and 1850, and was built specifically as a saddlery on an extremely narrow lot. There is a passageway on the ground floor that permits access to the rear of the house rather than requiring one to go around the house to the back. It is the only surviving example of such a passageway in Charlottesville.

Continue on East Jefferson, which in this block is called Court Square.

35. MONTICELLO HOTEL (500 COURT SQUARE)

Built between 1924 and 1926, this Georgian Revival hotel, designed by architect Stanhope Johnson of Lynchburg, replaced a row of nineteenth-century mercantile buildings. The first two levels of the building are fronted by a façade of Doric pilasters supporting a horizontal entablature with triglyphs. The top of the hotel is capped

by a huge cornice and a balustrade. The hotel is now converted into condominiums.

36. Farish House/Eagle Tavern (500 Court Square, east of the Monticello Hotel)

The original building on this site was the Eagle Tavern, built prior to 1791. In 1854, it was replaced by the current Greek Revival building and renamed the Farish House. It is three stories high with a recessed pavilion entrance. The façade has four pilasters with capitals that are formed out of molded brick, and the walls are one of the first examples of American bond brickwork in the city. This hotel housed about 250 people on court days during the late eighteenth and nineteenth centuries. It was at this hotel that the body of General Ashby Turner, killed during Jackson's 1862 Valley campaign, lay in state before his local burial.

37. Number Nothing (240–242 Court Square)

This building is called Number Nothing or Number 0 because the lot was an open space in the original city plan, and by the time it was sold, there was no number left on this street to use. This lot was bought in 1820 by Opie Norris and John C. Ragland. There were no improvements on the lot at that time, and a memorandum states that the ground between it and the Swan Tavern was to remain a public street or road, and not to be stopped up without the consent of both parties. This Federal-style structure was built in 1823. Each half of the building has always been separately owned.

Though Charlottesville did not have a slave market as such, slaves were auctioned in front of the courthouse, in front of the Eagle Tavern or by the Benson and Bro. Auction firm at Number 0. Tradition has it

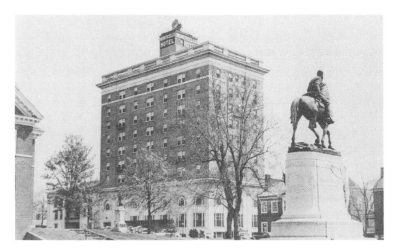

Monticello Hotel with the Farish House on the east side, circa 1925 (Everett Waddy Co.). *Collection of J. Tracy Walker III, Charlottesville, Virginia.*

that the stone block by the south side of the street next to this building was the auction block on which a variety of property, including slaves, was sold.

38. NINETEENTH-CENTURY SHOPS (218–230 COURT SQUARE)

Just east of Number Nothing is a row of small buildings that housed the shops of various artisans in early nineteenth-century Charlottesville. Starting with the building partway behind Number 0 and going south, there are the James Leitch Storehouse, built in 1820 and extensively renovated in 1961; the site of the original public library; the site of the shop of Lewis Leschot, a Swiss jeweler; and the site of the shop of John Yergain, seller of fine liquors. The present structures on the last three sites are mid-nineteenth-century brick buildings replacing the original wood-frame buildings.

Turn north on Park Street and walk past Number Nothing to the continuation of East Jefferson. Turn east, and walk one block to Seventh Street. Turn south onto Seventh Street.

39. EVERETT HOUSE (213 SEVENTH STREET NORTHEAST)

This wood-frame building on your right in the center of the block is a vernacular cottage, built before 1846, and is said to have been moved from Milton to Charlottesville. This house has undergone considerable renovation and only the interior staircase remains intact.

Continue south on Seventh to East Market Street, and turn right (west). Turn right on Fourth Street to see the Massie-Wills House, then return to East Market and continue west.

40. MASSIE-WILLS HOUSE (211–215 FOURTH STREET NORTHEAST)

This complex is Charlottesville's most outstanding example of Federal domestic architecture that survives in the Court Square area. Numbers 211 and 215 were originally separate houses. Both brick houses were built about 1830 by Harden Massie. 211 is a simple two-story, two-bay brick originally built one room deep, with a tin roof and a parapet on the southern gable. 215 is a two-story, three-bay house on a high basement, and still contains the original heart pine flooring and Jeffersonian wood mantels. 213 is the recessed section that was built about 1870 over the old carriage passage between the two houses.

41. FORMER SITE OF THE STONE TAVERN/CENTRAL HOTEL (414 EAST MARKET STREET)

Indicated by a historic marker at this address is the site of the Stone House, the first house purchased by James Monroe when he moved to Charlottesville. In 1789, the Monroes sold this house and lot to purchase a plantation that would later become the grounds of the University of Virginia. The Stone House became the Stone Tavern, and later the Central Hotel. It was at this hotel that the town fathers fêted the Marquis de Lafayette when he and Jefferson passed through

U.S. Post Office and Courthouse, Charlottesville, Virginia, circa 1906–08
(Leighton and Valentine Co.). *Collection of J. Tracy Walker III, Charlottesville,
Virginia*.

the town on their way to the university for the famous dinner in the
Rotunda in 1824.

42. DR. JOHN C. HUGHES HOUSE (307 EAST MARKET STREET)
Built in 1853–54, this lot was owned by Dr. John C. Hughes and then
sold in 1873 to Dr. William Cecil Dabney of the Dunlora Dabneys.
This Greek Revival–style brick house is two stories high above a high
basement, and three bays wide. The building has a two-story entrance
porch with coupled Ionic columns.

Turn right onto Third Street to see the Belk House, then return to
East Market and continue west.

43. BELK HOUSE (216 THIRD STREET NORTHEAST)
The Belk House is a two-story Colonial Revival brick structure with a
slate hip roof. It was built about 1900 by Warner Wood.

44. UNITED STATES POST OFFICE/JEFFERSON MADISON REGIONAL LIBRARY (NORTH SIDE OF EAST MARKET STREET BETWEEN SECOND AND THIRD STREETS)
This site was originally occupied by the Beth Israel Synagogue before
it was moved to 301 East Jefferson Street. The current building,
originally the U.S. Post Office, is a monumental Classical Revival
structure finished in April 1906 by contractor Miles and Brandt Co. of
Atlanta, Georgia. It was remodeled in 1936 by Louis A. Simon. The
main body of the structure is of brick, with marble steps and a marble
portico of six Ionic columns. The interior is decorated with Doric
pilasters supporting a full entablature with period ironwork around
the stairs. The building currently houses the Central Library of the
Jefferson Madison Regional Library.

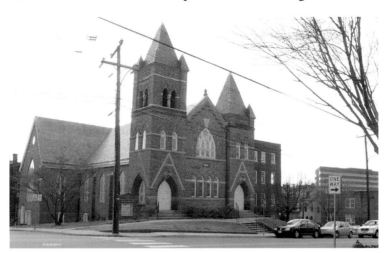

First Christian Church, Charlottesville, Virginia, 2007. *Author's collection*.

45. First Christian Church (Market Street at First Street)
This lot was originally purchased from Nancy West, a local free black businesswoman, for the Reformed Baptist Church. The current church building was completed in 1897, and is an example of the late Gothic Revival style, finished in brick with granite trim. The pointed windows with thick mullions, the splayed door reveals and pyramidal roofs with lead finials are characteristic of the Gothic Revival style.

Tour—The University of Virginia

http://www.virginia.edu
Thomas Jefferson called the buildings and grounds of the University of Virginia an "academical village." The original plan included two colonnades of buildings on either side of a wide lawn, with another colonnade behind them facing outward from the lawn. At the head of the lawn was the Rotunda.

The Lawn and Ranges are on a sloping, terraced hill with many stairways. Although the university has made efforts to make it handicap accessible, access may be difficult for those with mobility issues.

Walking Tour

1. The Rotunda
This central building is considered one of the most beautiful architectural achievements in the United States. It was designed by Thomas Jefferson and built primarily between 1822 and 1826. Jefferson intended it to be the focal point of the institution and the university's library. In fact, the Dome Room on the third floor of the Rotunda was the main library until Alderman Library was built in the 1930s. On the first and second

floors of the Rotunda were lecture rooms, including a chemistry room with an oven in which experiments could be heated. The Rotunda was severely damaged in a fire on October 27, 1895, and everything but the brick shell was burned. Architect Stanford White of the firm of McKim, Mead, and White guided the renovation of the building into a Beaux Arts version of the original. In particular, White increased the height of the Dome Room by eliminating the second floor of the building and increased the size of the oculus, or round skylight, in the dome. He also added a portico on the north side of the Rotunda. This new building was finished in 1898. From 1973 to 1976, the Rotunda underwent a restoration that removed the White changes and returned the building according to the plans designed by Jefferson. The new building was dedicated on April 13, 1976, the anniversary of Jefferson's birthday. (WHL, NRHP, VRL)

McKim, Mead, and White also designed the university president's[64] residence, CARR'S HILL, which was built in 1912–13 on a hill to the northwest of the Rotunda. This house is built in a Colonial Revival style, with a two-story Doric portico. North and west of the mansion itself are four small buildings that date to the mid-nineteenth century. These include remnants of the student dormitories that used to occupy this site, plus part of the student dining hall and a carriage house.

2. The Lawn

Looking south from the Rotunda is the lawn. On either side of the lawn are pavilions, which were the homes of the professors, connected by a continuous loggia with individual student rooms between them. Behind the pavilions, spreading east and west, are the private gardens, the public gardens and the ranges, which have additional student rooms situated between hotels. Students and professors still live on the lawn and ranges today. In fact, it is considered a great honor for members of the college in their final year of study to live on the lawn.

3. Cabell Hall

At the south end of the lawn is Cabell Hall, designed by Stanford White and built around the turn of the twentieth century. This building is the home of the Music Department. The front hall features an eleven-panel mural by Lincoln Perry entitled *The Student's Progress*, finished in 2000. This mural complements the George Breck copy of Raphael's *School of Athens* that is located in the Cabell Hall Auditorium.

4. Canada

Just south of Cabell Hall, now across Jefferson Park Avenue, was a neighborhood called Canada, which was the home of the laborers who worked at the university, many of them free blacks. In 1833, Catherine "Kitty" Foster, a free black or mulatto woman, bought property there on what is now Venable Lane. The Foster family continued to live here for ninety years, working as seamstresses and laundresses for the

faculty and students. In 1993, as a result of construction on that site, university archaeologists discovered twelve graves that they believed to be a Foster family cemetery. In 2005, another eighteen graves were discovered. A commemorative garden and interpretive monument at this cemetery site will be incorporated into the university's South Lawn Project, expected to be completed in 2010.

5. McIntire Amphitheater
Leave Cabell Hall, walk north to the sidewalk at the foot of the lawn and turn left. On your left is the amphitheater, which is used for concerts, plays and many other student activities. This was funded by Charlottesville philanthropist Paul Goodloe McIntire and designed by Fiske Kimball, the head of the Department of Arts and Architecture at the University of Virginia from 1919 to 1923. Kimball also served as the director of the Restoration Committee of Monticello from 1925 to 1955. He was active in restoration projects throughout Virginia and is noted as the force behind the revival of Thomas Jefferson's reputation as an architect. Shack Mountain (NRHP, VLR), Kimball's retirement home two miles north of Charlottesville, is an example of pure Jeffersonian Classicism.

6. Clark Hall and the Brown Science and Engineering Library
Walk past the amphitheater to McCormick Road. To your left, at the bend in the road, is Clark Hall, the home of the Environmental Sciences Department, as well as the Brown Science and Engineering Library. Renovated in 2004, this building was originally the university's Law School, and was donated by William Andrews Clark Jr. Inside the building is Mural Hall, which features a multi-part mural celebrating *The Law* by Allyn Cox, a well-known muralist who subsequently worked on murals and stained glass at the George Washington Masonic National Memorial and frescoes and murals at the U.S. Capitol. The Brown Science and Engineering Library was used as the Law School Library for a scene in the 1991 film *True Colors*.

7. Monroe Hill and Brown College
When James and Elizabeth Monroe moved to Charlottesville to be near their friend, Mr. Jefferson, the Monroes first bought a house in Charlottesville that was called the Stone House. In 1789, the Monroes sold that house and purchased a plantation on the site that became the University of Virginia. The small office on the site is Monroe's original law office. Monroe later moved to Highlands (now Ash Lawn), and eventually sold this property, part of which was later purchased as the site of the Central College. Sometime between 1806 and 1820, the main house was built, and until 1848 this building housed the university's proctor. In that year, the two arcades of rooms were built as dormitories for students. Now the complex houses Brown College, the university's first residential "college within the University."

8. West Range

13 West Range is the room that was used by Edgar Allan Poe when he was a student at the University of Virginia in 1826–27. It is open to the public.

9. Library Quadrangle

http://www.lib.virginia.edu

On the west side of McCormick Road is the library quadrangle, consisting of Alderman Library (the graduate library), Clemons Library (the undergraduate library) and the Harrison Institute/Small Special Collections Library. Near the road you will see a monument that commemorates Jefferson's Anatomical Theatre, which was demolished when McCormick Road was widened in the early 1930s. Alderman Library was completed in 1938, between this site and that of a former gatehouse to the university on the Three Notch'd Road. The university added Clemons Library in 1981, and in 2005 the new Harrison Institute.

"Declaring Independence: Creating and Re-creating America's Document" (http://www.lib.virginia.edu/small/exhibits/declaration/) is located in the Harrison Institute. This permanent public exhibit of the Albert H. Small Declaration of Independence Collection contains one of the university library's two copies of the first printing of the Declaration of Independence, plus materials and documents that illustrate the creation of the declaration and its growth into a cultural icon.

10. The Chapel

Jefferson originally designed the university without a chapel. It took more than fifty years before this non-denominational church was built to serve the university community. Charles Emmet Cassell of Baltimore designed the Gothic Revival building, dedicated in 1889.

Driving Tour

11. Memorial Gymnasium (Mem Gym)

As you drive south on Emmet Street (Route 29) past the main grounds of the University of Virginia, you will see Memorial Gymnasium just past the tennis courts on your left. This building was finished in 1924, and was intended as a memorial to the university's World War I casualties. Designed by architect Fiske Kimball, it is a multi-purpose auditorium used for both sports and performance events. On June 10, 1940, during a visit to the Charlottesville area, President Franklin D. Roosevelt was first informed of the alliance between Italy and Nazi Germany, and expressed his opinion of that alliance in his "Stab in the Back" speech given here in Mem Gym.

12. Piedmont (121 Mimosa Drive)

Continue south on Emmet Street. Go under a low bridge (It is very low! Don't attempt to go under it with a vehicle taller than ten feet, such

as a moving van.), and follow Stadium Road as it forks to the right. At the four-way stop at Maury Avenue, go straight across the intersection. Stadium will then take a sharp left; drive one long block, and you will see Mimosa Drive. Piedmont is the big white house ahead on the right. This was the home of Jesse Lewis Maury, a professor at the university, and was used as headquarters by General George Armstrong Custer during part of his occupation of Charlottesville from March 3–6, 1865. (See Chapter 5.) At that time, this was the center of a plantation on the outskirts of the university. While building the dormitories west of here, the university discovered a slave cemetery, which is marked by a monument in the courtyard between two of the dorms.

13. University Cemetery

Retrace your route back to the intersection of Stadium Road and Maury Avenue. Turn left; the road is now called Alderman Road. On the right, just past the intersection of Alderman and McCormick Road, is the University Cemetery. The cemetery is partitioned into two sections, the University Cemetery and the Confederate Cemetery. The first burial in the university section, which took place in 1828, is that of Dr. William Henry Tucker (1789–1828), a graduate of the College of William and Mary and the younger brother of university professor George Tucker. The first student buried here was John Temple (1808–1828), who died during a typhoid epidemic in the area. Some of the individuals buried in this section include Professor John A.G. Davis, shot in 1840 during a student riot; Professor William Holmes McGuffey (died 1873), author of the McGuffey Readers; and Dr. Edwin Anderson Alderman, first president of the university and the namesake of Alderman Library. The Confederate section contains the graves of 1,097 Confederate soldiers who died at the Charlottesville General Hospital and a monument to their memory, dedicated in 1893. On the east side of the driveway, you will see two graves set apart. These are the graves of Beta (died 1939) and Seal (died 1953), the university canine mascots.

Tour—Side Trips

1. Leander J. McCormick Observatory, University of Virginia
http://www.astro.virginia.edu/public_outreach/pubnite.html
Though Robert McCormick of Rockingham County, Virginia, invented the mechanical reaper, it was his sons Cyrus, Leander and William McCormick who obtained the patents on the machine and established the McCormick Harvesting Machine Company in Chicago. In 1870, Leander McCormick decided that he was going to donate the world's largest refracting telescope to his home state and chose the University of Virginia as the site. Due to delays caused by the adverse financial impacts of the Civil War and the Great Chicago Fire on McCormick's company, by the time the telescope was

finally built and installed by Alvan Clark & Sons of Cambridgeport, Massachusetts, in 1877, it was actually the second-largest telescope in the world. At forty-five feet, the dome housing the telescope was the largest in the world when completed, and was designed by Warner and Swasey with a unique three-shutter design. The telescope and building of the Leander J. McCormick Observatory were opened in 1885. The telescope is the only Alvan Clark telescope in existence still in its original Clark mount.

The observatory is still in use today, primarily for teaching and public outreach. It is open to the public two evenings a month.

2. McCormick Farm
http://www.vaes.vt.edu/steeles/mccormick/mccormick.html
This farm in Walnut Grove, Virginia, where the original reaper was invented is open to the public year round.

3. Fan Mountain Observatory, University of Virginia
http://www.astro.virginia.edu/public_outreach/pubnite.html
Fan Mountain Observatory, located thirteen miles south of Charlottesville near Covesville, was established in the mid-1960s to escape the increasing light pollution in the Charlottesville area. It is open to the public twice per year, once in April and once in October.

Read More About It

Alexander, James. *Early Charlottesville: Recollections of James Alexander, 1828–1874.* 1963 notes and revisions by Velora Carver Thomson. Charlottesville: Albemarle County Historical Society [Printed by The Michie Company], 1963.

Bruce, Phillip Alexander. *History of the University of Virginia, 1819–1919: The Lengthened Shadow of One Man.* New York: Macmillan, 1921.

McGehee, Minnie Lee. *Mr. Jefferson's River: The Rivanna.* Palmyra, VA: Fluvanna County Historical Society, 2001.

Rawlings, Mary. *The Albemarle of Other Days.* Charlottesville: The Michie Company, 1925.

————. *Ante-Bellum Albemarle.* Charlottesville: Albemarle County Historical Society, 1974.

Chapter 5

Central Virginia and the War Between the States (1860–1865)

I n the last decade before the Civil War, Charlottesville and Albemarle County, while still rural, had many "modern" features. Though most roads were still made of dirt and gravel, Main Street in Charlottesville was macadamized.[65] In 1857, gas lighting was available to homes and offices within a restricted area in the town. Albemarle County had four banks and an insurance company. By the late 1850s, central Virginians could travel long distances by way of the railroads, which were linked to the major transportation hubs of Lynchburg, Richmond and Washington, D.C., via the Orange and Alexandria Railroad, and to the Shenandoah Valley via the Virginia Central Railroad. The county even had a telegraph line—the line from Lynchburg to Charlottesville was finished in April 1860, which completed the line from New York to New Orleans—and there was also a telegraph line from Charlottesville to Scottsville.

By the 1860s, Albemarle County was the fourth richest county in Virginia. It was a primarily agricultural county, dominated by a group of about one hundred well-to-do farmers, many descended from the original settlers of the area. Their property was concentrated in the ownership of land and slaves. As John Adams and Thomas Jefferson had predicted, Southern slavery became a key component of the issues and conflicts that combined to precipitate the Civil War.

The majority, though not unanimous, sentiment in Charlottesville in 1860 and 1861 was in favor of states' rights and for secession from the union. In Albemarle County, the majority vote in the 1860 presidential election was for the Constitutional Union Party candidate, a conservative group formed in opposition to the Republicans and the radical Democrats. William Cabell Rives, a county resident and former U.S. senator and minister to France, represented Virginia at the Washington Peace Convention, seeking a compromise that would keep the union together. When the attempts at compromise failed, even the moderates in Albemarle County began to urge Virginia to secede.[66]

Even before Virginia voted for secession on April 17, 1861, university students formed two military units, the Sons of Liberty and the Southern Guard. The city matched them with the Albemarle Rifles and the Monticello Guard. These four units cooperated in April 1861 in an effort to capture the arms and ammunition stored in the Federal arsenal at Harper's Ferry, but by the time they arrived the Federal soldiers had removed the supplies and burned the buildings.

When the troops returned to Charlottesville, the student units were disbanded because the faculty believed they would serve the Confederacy better as officers in their home units. Of the 600 students enrolled at the University of Virginia in 1860, 515 of them had enlisted in the Confederate army by the end of 1861. Several of the faculty had also enlisted. Although the university's enrollment during the war years was only fifty to sixty students, academic lectures continued. The University School of Medicine continued to function as well, the medical students assisting in the hospitals, and there was only one year in which there were no graduates.

All told, Albemarle County raised twenty-one companies for the Confederate army. The two already-formed city units were mustered into the Nineteenth Virginia Infantry Regiment (one of the three brigades under the command of Brigadier General George E. Pickett, in Longstreet's Corps of the Army of Northern Virginia) as Companies A (Monticello Guard) and B (the Albemarle Rifles). Company C of this regiment was the Scottsville Greys; Company D, the Howardsville Greys; Company E, the Piedmont Guards from Stony Point; Company F, the Montgomery Guard of Albemarle County; and Company K, the Blue Ridge Rifles from Hillsboro in western Albemarle. Company G (the Nelson Grays) was from Nelson County, and Companies H (the Southern Rights Guard) and I (the Amherst Rifles) were from Amherst County, both parts of Old Albemarle County. The Nineteenth Virginia participated in ten battles, including First Manassas, Williamsburg, Seven Pines, South Mountain and Antietam, and charged up Cemetery Hill with Pickett at Gettysburg.[67]

Though Albemarle County was surrounded by strategic targets— the Shenandoah Valley was thirty-five miles west of Charlottesville; Gordonsville, the site of a major Confederate supply warehouse and railroad junction, was twenty miles northeast; and Richmond, the capital of the Confederacy, was only seventy miles away—no major battles occurred here. Charlottesville was, however, a key transportation center; with two major railroad lines crossing in Charlottesville, the city was a transfer point for troops and supplies. Henry C. Marchant's cloth mill on the Rivanna to the east of town produced heavy gray fabric used for Confederate uniforms.

The primary service of Charlottesville to the Confederate war effort was as a hospital center. Though the city did not have a public hospital prior to 1861, its location at the crossing of the railroads made it a convenient place to receive the wounded from field hospitals such as

the Exchange Hotel in Gordonsville. When the Confederacy asked the town and university to provide medical services, Charlottesville did its part for the cause.

For the first year of the war, many of the university buildings, including the Rotunda, served as hospitals. There were four hospitals in Albemarle County: Charlottesville General (which was spread out over several buildings), Midway Hospital, Delevan Hospital and Scottsville Hospital. The town hall and the courthouse, as well as many private homes, also housed sick and wounded soldiers. In 1862, however, the Board of Visitors of the university prohibited the use of university buildings as hospital facilities, because they thought such use would prevent the restoration of the university as a place of education after the war.

University professors Dr. James Lawrence Cabell and Dr. John Staige Davis were commissioned in the Medical Corps of the Confederate army, and Cabell was put in charge of the Charlottesville General Hospital. Many other physicians offered their services, including Dr. Oriana Moon of Scottsville, who was a graduate of the Women's Medical College of Philadelphia. Moon met her future husband, Dr. John S. Anderson, during her service in Charlottesville, and the two of them practiced in Scottsville after the war.

At any given time, there were between 1,000 and 1,200 patients in the hospitals of Charlottesville. All in all, the hospitals in Charlottesville treated approximately 22,700 patients, of whom about 5,400 were treated for gunshot wounds. The rest suffered from various diseases, including dysentery, typhoid fever, pneumonia and measles. Of those who died in Charlottesville, 1,097 were buried in the Confederate Cemetery next to the University Cemetery.[68]

THE WAR IN CENTRAL VIRGINIA

In May 1862, General Robert E. Lee sent Stonewall Jackson to the Shenandoah Valley to hold off a large Union force from joining McClellan and to defend Winchester. This particular campaign was the one in which Jackson demonstrated his brilliant mind for military tactics, as he managed to outwit a Union force of more than 60,000 with his 16,000 men. He moved his army so fast that the Union generals (and his compatriot, General Ewell, as well) were bewildered. At one point, it even seemed that Jackson and his army had disappeared. In fact, Jackson had led his men east from the Valley through Brown's Gap in the Blue Ridge into Albemarle County, and passing through White Hall in western Albemarle, had reached Mechum's Station (near the intersection of Routes 250 and 240) on the Virginia Central Railroad. Jackson's army went by train to Staunton and joined Johnson in repulsing a Federal attack at McDowell, Virginia.

Merely a year later, Stonewall Jackson was wounded in the battle of Chancellorsville, and died on May 10, 1863, of pneumonia. Citizens

throughout the Confederacy mourned the death of "Lee's right hand." Jackson's body lay in state in Richmond, and then was taken to Lexington for burial. The cortege traveled by rail to Gordonsville, then through Charlottesville to Lynchburg and then the packet boat *John Marshall* carried the body to Lexington along the James River and Kanawha Canal.

> *The passage through Charlottesville was a memorable occasion. By the mayor's proclamation, all business activities were suspended and all church bells were tolled while the train bearing Jackson's body passed through the city. People gathered along the tracks and especially at Union Station where a brief stop was made. There were no speeches and no ceremonies, just desolate grief.*[69]

The only Civil War "battle" fought in Albemarle County was a skirmish at Rio Hill on February 29, 1864. As part of a diversion by the Union army to distract Confederate attention from a Union raid on Richmond intended to free Federal prisoners being held there, General George A. Custer was ordered to deploy toward the Confederate left flank in the direction of Charlottesville and to destroy the railroad bridge over the Rivanna at that point, if possible.

Custer reported,

> *I found Charlottesville and the bridge over the Rivanna guarded by four batteries of artillery, two brigades of cavalry, and a very large force of infantry. This will be sufficient reason for my not having destroyed the railroad bridge, but I destroyed the five frame bridges over the stream, within two miles of the railroad; captured and destroyed a large camp of the enemy after driving them from it.*[70]

In addition to burning bridges, Custer's force burned the Rio Mills and a few fences and outbuildings of local farms, persuaded a number of slaves to join them and took horses for the use of the army. Then they retreated, their job as a diversion complete. The successful Confederate cavalry commander Captain Marcellus N. Moorman related that only two men were captured, along with a number of horses, and that the main loss was tents, harnesses, blankets and clothing, as well as personal effects.[71]

In mid-June 1864, being informed that the Army of the Shenandoah was en route to Lynchburg, Confederate General Jubal Early raced his men toward the Charlottesville rail center. The Second Corps reached Charlottesville on June 17, after having marched eighty miles in four days. Only half of Early's forces could be transported to Lynchburg on the rolling stock available, so half of them had to continue the march on foot while waiting for the trains to come back and pick them up. By using subterfuge, Early managed to convince Union Major General David Hunter, commanding the Army of the Shenandoah,

that he was outnumbered, and the Federal forces retreated to continue down the valley.

On February 20, 1865, General Philip Sheridan received orders to proceed south to Lynchburg to destroy rail and canal facilities. He was in command of two divisions of cavalry (a total of 10,000 men) headed by Generals George A. Custer and Wesley Merritt. General Early, learning of Sheridan's advance, ordered the approximately 1,200 men left to him to break winter camp and proceed to Waynesboro. There, on March 2, the severely outnumbered and under-armed Confederates were routed by one charge of Sheridan's army, and nearly every man in the Confederate force was taken prisoner. This Union victory left the road eastward toward Richmond unguarded.

General Custer led the vanguard of the Union army as it moved toward Charlottesville. Crossing the Blue Ridge at Rockfish Gap, the army destroyed a tannery at Brooksville and captured Greenwood Depot, destroying what Custer described as "an immense quantity of government stores and cotton."

On March 3 and 4, 1865, Mary Randolph Garrett of Clover Plains[72] described the Federal advance in a letter to a friend: "In a few moments Mary Thomas came running in to tell cousin Bev that a man had been here and asked for him, told the servants to tell him that our army was completely demoralized and that [Confederate General Jubal A.] Early and staff was captured. At the same time people were just tareing [tearing] down the road. I never saw people go so fast in my life." As the Confederates retreated from the Union army, the Yankee soldiers began to loot and burn property, stopping at the households as they passed down the mountain road. "Some Yankees said they were going to burn the next [two] depots and then go to Charlottesville and burn the University, and proceed to Lynchburg…The guard said you dont [sic] know what this country will be, when we have done with it you don't know what desolation is."[73]

Custer arrived at Charlottesville on March 3 around four o'clock in the afternoon, where a delegation of citizens formally surrendered the town and awarded him with the keys of all the public buildings. In this group were Captain Christopher Fowler (the mayor), several members of the town council and three representatives of the university— Professor John B. Minor, Dr. Socrates Maupin (the chairman of the faculty of the university) and Colonel Thomas L. Preston (the rector of the Board of Visitors). Professor Minor's diary describes the scene.

Between one and two o'clock [in the afternoon of March 3], *we repaired to the grounds opposite Carr's Hill*[74]*…and there awaited the enemy's coming. Our town friends had already arrived, and had displayed a flag of truce, and in a short time the enemy's scouts were visible at the old toll gate* [near the university gatehouse]*…We announced to these men, who were accompanied by a dirty-looking lieutenant, that no defense of Charlottesville was contemplated, that the town was evacuated, and that we*

requested protection for the University, and for the town…In a few minutes a good looking officer rode up, who announced himself as Gen Custer's adjutant general, I believe, and upon our restating our wishes, said a private guard would be furnished the University, and private property everywhere would be protected.[75]

In return for this surrender, Custer promised to spare the university buildings and private homes in the town, which he did, though guards from the army had to be assigned to each protected building to prevent random looting. Most of the houses were searched for arms and food, but no buildings were burned in town, not even the railroad depot.[76] Many of the houses belonging to the richer residents were taken over by the Union officers. General Sheridan had his headquarters first at John Woods's, and then at Miss Betsy Coles's.

Primary sources and local legend state that Custer stayed at the Farm, then the residence of Mr. and Mrs. Thomas Farish. There are several memoirs that state Custer also stayed at Jesse Lewis Maury's Piedmont plantation near Fry's Springs while he was in Charlottesville, but it is not known if that was before or after his stay at the Farm. The house at Piedmont was severely damaged, and foodstuffs and other belongings either taken by the Union troops or destroyed. In a letter written by Susan Leigh Blackford on March 6, she talks about the damage at Piedmont.

They went to Mr. Jesse Maury's and ransacked the house, although General Custer made his headquarters there…General Custer sat in the dining room while all this was going on. Lizzie Maury found a teaspoon on the floor which had fallen out of the pocket of one of the intruders. She picked it up, carried it to General Custer and asked him if he dropped it. He was very indignant but she pretended to a great innocence of motive.[77]

The troops bivouacked in the vacated dorm rooms of the University of Virginia, several churches and taverns, or camped around the town. Sarah Ann Strickler, then a student at the Albemarle Female Institute, said in her diary, "They are encamped all around here; the hundreds of camp fires are gleaming brightly in the dark."[78]

John Singleton Mosby, the famed Gray Ghost of the Confederacy, was an Albemarle native. When Sheridan's army arrived in Charlottesville, Mosby and another Confederate officer happened to be in the town on furlough. They had stopped at a local barbershop for a shave. John West, the barber's apprentice (and a well-known businessman in the city in later years), notified Mosby of the arrival of Sheridan's troops in the middle of his shave. Jumping up from the barber's chair with his face covered in lather, Mosby and his friend leapt onto their horses and headed north out of town, with West's warning not to take Park Street only half heard. Mosby ran right into the Union guard already on Park Street, but the Confederates' horses bounded over the pickets

in a great leap, and they escaped before the startled guard could stop them.

General Merritt reported that between March 3 and March 6, "The column, as it marched, destroyed all Confederate Government property on its route, as well as the railroad bridges, depots, &c., between Staunton and Charlottesville."[79] Work details destroyed the Virginia Central Railroad tracks north and south of town, demolished the railroad bridges across the Hardware River on the route to Lynchburg, burned the Free Bridge[80] on the east side of town and cut the telegraph lines to Charlottesville. The army also destroyed some two thousand pounds of tobacco; fifteen wagons loaded with corn, wheat and other supplies; Marchant's mill and the railroad bridge over the Rivanna there; and a tannery with one thousand hides in Charlottesville. And at Ivy Depot, the Union forces had destroyed the water tanks and warehouses containing tobacco and commissary stores. Many homes in the surrounding county were stripped of food, livestock, silver and other valuables—what was not taken was frequently destroyed—and many enslaved blacks chose to join the army as it passed through the area. (In Sheridan's report on the campaign, he reported that two thousand former slaves followed the army as it marched down the James toward Richmond.)

When Sheridan left Charlottesville, he split his forces. The First Division, led by General Merritt and Colonel Thomas Devin, advanced to Scottsville with orders to burn all accessible bridges, mills and locks on the James River Canal. The Third Division, under the command of Sheridan and Custer, followed the Lynchburg Road south. Their mission was to destroy the tracks of the Virginia Central Railroad.

At this time, Scottsville was a prosperous port on the James River. Though the town supported the Confederate cause, the war had not reached that far into central Virginia. The port was used to ship troops and supplies up and down the James. Knowing that the arrival of the Union forces was inevitable, many of the residents of Scottsville evacuated. On March 6, 1865, entering the town of Scottsville by the Valley Road (Route 20), the Union soldiers dynamited the canal and locks, and three fully loaded packet boats found in the loading basin were burned to ashes. Once the canal was thoroughly destroyed, Merritt gave the order to torch any buildings of potential military service. Beal's flour mill, the candle factory, the woolen factory, a machine shop, a tobacco warehouse and nearby stables were torched. Union Brigadier General Alfred Gibbs reported, "I regret that a few private dwellings, close to the mill, were more or less charred by the intense heat."[81]

Within a few hours, having done as much damage as they could in Scottsville, the first division headed west along the north bank of the James, destroying every canal lock as far as Howardsville.

Merritt and Devin reunited with Sheridan and Custer at New Market, Virginia. They needed to cross the James to join General

Grant, but the Confederates had destroyed all the bridges. So they headed east, back to Scottsville. On March 9, the now ten-thousand-strong army marched once again into Scottsville, where they bivouacked and resupplied in preparation for the march to Richmond. Sheridan and Custer took Cliffside as their headquarters, Merritt took Old Hall and Devin was at Driver's Hall. On the morning of March 10, before heading his army east toward Richmond, Sheridan ordered the burning of the Columbian Hotel. The fire was so intense that it spread to nearby buildings, eventually burning the entire lower block of the town.[82]

All in all, in nine days' time, Sheridan and his army destroyed fifty miles of railroad track in Albemarle County, wrecked bridges and culverts, mills and warehouses, burned tobacco and cotton stores, stripped the populace of food and livestock and destroyed millions of dollars' worth of property. And within a month, General Lee would surrender to General Grant at Appomattox, and the people of central Virginia would begin to pick up the pieces of lives drastically different from before the war.

Tour—Northwest Albemarle

On this driving tour, you will get to see parts of the county's rural west, bordering on the Shenandoah National Park. Take Route 29 north to Hydraulic Road (Route 743) and turn left.

1. Hydraulic Road
On the east side of the intersection of Route 29 and Hydraulic is the location of the old fairgrounds, which later became a drive-in movie theater and now is a supermarket. Following Hydraulic Road, you will pass Albemarle High School on your left. Hydraulic intersects at that point with Lambs Road, which was the route by which the Convention Army marched to its new quarters at the Barracks Farm. The road is no longer a through road, however. Continue on Hydraulic to its intersection with Earlysville Road.

2. Ivy Creek Natural Area
http://ivycreekfoundation.org/
A half-mile after you turn onto Earlysville Road, before you cross the South Fork Rivanna Reservoir, you will see a sign for Ivy Creek Natural Area on your left. This 215-acre preserve was a gift from the family of Hugh Carr, a former slave who had belonged to Richard Woods Wingfield of Woodlands (see number 3). In 1875, after working as a laborer for some years after the Civil War, Carr became the farm manager of Woodlands. He gradually purchased land in this area, which he named River View Farm. The Nature Conservancy purchased the property in 1975. The property has the 1883 farmhouse built by Hugh Carr, a family cemetery, a 1930s barn and an education center. The Natural Area also has an overlook to the site of Hydraulic

Mills, a village that was flooded in the creation of the reservoir in 1966. The area has seven miles of walking trails and many public programs throughout the year.

Leaving Ivy Creek Natural Area, turn left onto Earlysville Road and then left again on Woodlands Road (Route 676).

3. WOODLANDS

The Woodlands property, originally built by the Wingfield family and still owned by them today, was sited between the South Fork of the Rivanna and Ivy Creek. The main house, built in 1842–43, still stands, with some late nineteenth-century renovations, as does an antebellum barn, the oldest building on the property. The house is easily visible from Woodlands Road, on the south (left) side.

Follow Woodlands Road until it dead ends into Free Union Road (Route 601) and then turn right.

4. FREE UNION

This area was first settled around 1761, about the time Albemarle County received some land from Louisa County as the counties were realigned. The first families to live in this area were the Harris and the Maupin families. Originally called Nicksville, the name was changed to Free Union after the "Free Union" Church that was built there in 1837. The church housed a union of four denominations— Baptist, Methodist, Episcopalian and Presbyterian—because none of the congregations could afford to build a church by themselves. The church was free to all races—that is, services were attended by both whites and enslaved blacks—so it became known as Free Union Church. That original Classical Revival building is now the home of Free Union Baptist Church.

5. BROWNS GAP AND SHENANDOAH NATIONAL PARK

http://www.nationalparkreservations.com/shenandoah.htm

Continue past Free Union on Route 601. When Free Union Road dead ends into Boonesville Road (Route 810), turn left. The road soon changes its name to Blackwells Hollow Road, but remains Route 810. In about two miles, the paved road will take a sharp turn to the left, and a gravel road goes off to the right. This gravel road leads to Browns Gap, and is the beginning of the Browns Gap Turnpike, originally built about 1805–06. Unfortunately, the road is closed at the point where it enters Shenandoah National Park, so the only driving route to Browns Gap is via the park's Skyline Drive, entered farther south at Rockfish Gap. However, if you are energetic, park at the end of Browns Gap Turnpike and hike the Browns Gap Fire Trail to Doyles River Trail in the park. This is a scenic hiking trail about seven miles long with some fairly steep sections.

The turnpike was apparently not a money-making enterprise, and though it was one of the primary routes across the Blue Ridge in the

early nineteenth century, by 1867 it was a free public road. The gap is named after the Brown family, who owned land in this area on both sides of Doyles River since before 1742. It was through Browns Gap that Stonewall Jackson routed his army in 1862 and then marched them down the turnpike to Mechum's Depot to entrain for Staunton.

6. BROWNS COVE

Continue south on Browns Gap Turnpike (Route 810) through Browns Cove. (A "cove" is a small valley in the side of the mountain.) Browns Cove was settled by Benjamin Brown Sr. and his family[83], who eventually owned ten thousand acres in this area. The turnpike follows Doyles River until it joins the Moormans River just before White Hall. Along this stretch, you will see a number of farms, orchards and vineyards. After the Civil War, the farmers of western Albemarle realized that they could no longer compete with the Midwestern states in producing grain crops such as corn and wheat. Instead, they turned to specialty products, especially orchards of apples and peaches, and vineyards.

7. INNISFREE VILLAGE

http://www.innisfreevillage.org/

At the junction of Routes 810 and Walnut Level Road (Route 668), the paved road takes a sharp left. To the right is a gravel road leading to Innisfree Village. Innisfree, founded in 1971, is a nonprofit community for people with mental disabilities. Handmade products from the bakery, weavery and woodshop are sold at the Charlottesville Farmers' Market and other local shops. Innisfree World Artisans is a store in the Charlottesville Downtown Mall that sells products by the Innisfree artisans as well as from artists around the world. Call before visiting.

8. MOUNT FAIR

Following Route 810 to the left, in a half-mile, at the junction of Route 810 and Slam Gate Road (Route 673), you will see Mount Fair on a hill on the west side of the road. Mount Fair is one of the properties that was owned by the Brown family, and it is one of the best preserved farms in the area. The main house is a two-and-a-half-story frame building on a raised basement in the Greek Revival style. The current building was erected about 1848 by William Brown on the foundation of the original house, which burned about 1845. The farm complex includes a detached kitchen, an icehouse, a springhouse, ruins of slave quarters and family and slave cemeteries. (NRHP, VLR)

MONTFAIR FARM RESORT (http://www.montfairresortfarm.com/) is located near Mount Fair on property that once was part of the Brown family's holdings.

9. SUGAR HOLLOW RESERVOIR

Continue south on Route 810 for about two miles, until you come to a sign for White Hall Vineyards. This is Break Heart Road (Route

673). Turn right onto Break Heart Road, continue for a mile and then turn left onto Sugar Ridge Road (Route 674), a gravel road. Passing White Hall Vineyards, Sugar Ridge Road continues for slightly over a mile, then intersects with Sugar Hollow Road (Route 614). Turn right onto this road and parallel the Moormans River to the Sugar Hollow Reservoir. This reservoir was completed in 1949, and is one of the three main sources of water for Charlottesville. The reservoir is stocked with trout for fishing. It borders on the Shenandoah National Park and includes hiking trails into the park, as well as trails around the reservoir and several swimming holes.

Also on Route 614 near the reservoir is the Inn at Sugar Hollow Farm (http://www.sugarhollow.com/)—a bed-and-breakfast that offers accommodations in two buildings, one of which is a renovated farmhouse built about 1900—and the Girl Scout Camp Sugar Hollow (http://www.gsvsc.org/c_sugarhollow.htm).

10. White Hall

Leave Sugar Hollow Reservoir going east on Route 614. This road intersects with Route 810 at White Hall. A half-mile before the intersection on the south side of the road is Mount Olivet Baptist Church, an African American congregation that was established in the 1890s. The village was called by several names prior to about 1835, when the name White Hall took hold. Some of the early business names, Glenn's Store, Maupin's Store and Miller's Tavern, reflect the names of the predominant families in the area. Mount Moriah Methodist Church still meets in its 1834 church building located a half-mile east of the intersection on Route 614, on the north side.

This site is known for having two prosperous country stores, the Piedmont Store and Wyant's Store. The original 1840s Piedmont Store building still stands behind the present concrete block building. Some of Stonewall Jackson's troops are said to have camped near the Piedmont Store during their 1862 march. Wyant's Store was established in 1888; the current building is from 1918, built after the original burned. A number of the houses in this area are from the nineteenth century, including 2907 Browns Gap Turnpike, which was built about 1810.

11. Mechum's River and Depot

Continue south on Browns Gap Turnpike (Route 810). About a half-mile south of the intersection, where Route 810 becomes White Hall Road, turn left onto Route 680. This is the original route of Browns Gap Turnpike, and the route that Jackson's army would have taken in 1862. This road is about four and a half miles long. A quarter-mile after passing over the Garnett Dam at Beaver Creek Lake, look for Old Three Notch'd Road (Route 802), a sharp right. The first building on your left on this road is Mountain Plains Baptist Church, established in 1812. This church was severely damaged in a fire in the

D.S. Tavern, date unknown. This photograph was taken before the widening of Route 250, which now runs within fifty feet of the house, now House of Jacobus Antiques. *Milton Waff Collection, Albemarle Charlottesville Historical Society, Charlottesville, Virginia.*

nineteenth century, but was rebuilt on the original plan. Return to Browns Gap Turnpike (Route 680) and continue south. The last house on this road, before it intersects with Three Notch'd Road (Route 240) and Route 250, is 1207 Browns Gap Turnpike, built about 1790. At the intersection, you will see the railroad bridge over Mechum's River. A few hundred feet to the west of the bridge is Mechum's Depot, where Jackson and his men took the train for Staunton after their march.

12. D.S. Tavern

Turn left onto Route 250, heading back toward Charlottesville. As you drive east on Route 250, you will pass a number of large estates, including the original site of Locust Hill, the childhood home of Meriwether Lewis. Between Ivy and Charlottesville, stop and visit the D.S. Tavern, now House of Jacobus Antiques (3449 Ivy Road). The nucleus of the two-story, single-pile section of the frame structure is a one-room log cabin built about 1740, possibly as a claims house on the Three Notch'd Road. "D.S." is traditionally attributed to David Stockton, who blazed the trail from Williamsburg to Goochland and carved his initials in a tree where he separated from his partner Michael Woods. This tree marked the zero mile of Three Notch'd Road and the location where it intersected with Richard Woods Road from the Blue Ridge. Unfortunately, the tree was a casualty when Route 250 was widened in the 1970s. As late as the 1870s, the D.S. Tavern was the only building on the road between Ivy and Birdwood Plantation on the west side of Charlottesville.

13. BIRDWOOD

http://www.boarsheadinn.com/activities/birdwood/

Continue east on Route 250. You will pass the Boar's Head Inn on your right. A mile or so farther east, you will see Birdwood Golf Course on your right. Birdwood was originally a plantation built on land patented in 1739. The house, Birdwood Pavilion, was built in 1819 by workmen who would later build the University of Virginia Rotunda. The property now belongs to the University of Virginia, and is open to the public as Birdwood Golf Course.

On the north side of Route 250, across from Birdwood, were four large houses that a former Birdwood owner, Hollis Rinehart, built for his sons between 1921 and 1924.[84] The most easily seen from the road are Boxwood, built for his son William, which once housed the Institute for Textile Technology; and Kenridge (called Colridge by an interim owner), built for himself. Boxwood is now the home of a division of the National Radio Astronomy Observatory (NRAO). Kenridge was for many years the national headquarters of Kappa Sigma fraternity, and is now the centerpiece for a planned residential community.

READ MORE ABOUT IT

Ayers, Edward L. *In the Presence of Mine Enemies: War in the Heart of America, 1859–1863.* New York: W.W. Norton, 2003.

Coffey, David. *Sheridan's Lieutenants: Phil Sheridan, His Generals, and the Final Year of the Civil War.* Lanham, MD: Rowman & Littlefield, Publishers, 2005.

Jordan, Ervin L., Jr. *Charlottesville and the University of Virginia in the Civil War.* Lynchburg, VA: H.E. Howard, Inc., 1988.

————. *Nineteenth Virginia Infantry.* Lynchburg, VA: H.E. Howard, Inc., 1987.

Osbourne, Charles C. *Jubal: The Life and Times of General Jubal A. Early, CSA, Defender of the Lost Cause.* Chapel Hill: Algonquin Books of Chapel Hill, 1992.

Chapter 6

Charlottesville and Albemarle County in Post-bellum Virginia (1865–1925)

I n 1870, Albemarle County had slightly more than twice the population it had had in 1830. Of the 27,544 people, 14,994 were black and 12,550 were white. Charlottesville itself had 166 families living in 160 homes, with a total population of 2,838.[85] Mr. W.W. Waddell described the town as it was when his family moved to Charlottesville.

> *The area covered by Charlottesville in 1875 was practically from West High at the top of Beck's hill to East High where it turns to the River Road and from there across to the Chesapeake & Ohio Depot, up to the C. & O. Railroad via Garrett Street to the Junction and back by the Gas House to Beck's Hill…The town was surrounded by about half a dozen large farms. On the northeast the Sinclair Estate ran up to High Street and down to the river, the section now known as Locust Grove. On the East Captain Thomas Farish's farm [the Farm] came up close to High Street. On the Southeast and South the Brenner Estate and Mr. Slaughter Ficklin's farm ran to the C. & O. Depot. On the Southwest was the Fife Estate which is now covered by Fifeville and ran up to the Southern Railroad. The Colonel T.L. Preston and Andrew J. Craven farms were on the Northwest and North and extended to the old line of the Southern Railroad. This section is now Preston Heights and Rose Hill.*[86]

Many changes occurred due to the South's defeat in the Civil War. In Albemarle County and Charlottesville, it was no different. Whites either attempted to sustain the antebellum way of life, attempts that would prove unsuccessful over time, or took control of their fates by embracing their new world and making the best of it. Freed blacks had to find a way to navigate the joys and hazards of their new freedoms. In general, the people of the county were relatively subdued in their reactions to the new milieu. There is no evidence that the Ku Klux Klan was active in the area during Reconstruction.[87]

For the first two years after Lee's surrender, blacks, while legally free, generally continued working in similar conditions and relationships as before the war, except that they were paid for their work or worked the land under a system of sharecropping. As freed blacks moved off the county's plantations, many moved to Charlottesville in order to find jobs. The former Delevan Hospital became once again a hotel, nicknamed "Mudwall" for the red brick wall surrounding it, and was the home of many freed men and women. In the early 1880s, the First Colored Baptist Church bought the site, and in 1883 completed the building that now stands there.

The first exercise of the former slaves' new freedom was in education. In 1865, most blacks could neither read nor write, because it had been illegal to teach those skills to a slave. Miss Anna Gardner, an ardent abolitionist from Nantucket, Massachusetts, was the first to set up a school for ex-slaves in Charlottesville at Delevan. By April 1866, there were more than 250 ex-slave students enrolled in Miss Gardner's school. Within three years, the Albemarle freedmen's schools were divided by a graded system, with primary and intermediate (Lincoln School) grades, and a teachers' school (Jefferson School).

Virginia had never instituted a public school system for whites, and until 1870, students were schooled at home or attended a private academy for a fee. Because the freedmen's schools were so effective, it became apparent that Virginia needed to establish a general system of public schools statewide. W.H. Ruffner and John B. Minor of the University of Virginia designed the new school system, which took effect in 1870. In 1871, the first Albemarle County public school to open under the new system was in Scottsville. In Charlottesville, one of the first public schools for whites was built on the site of the old Midway Hospital.[88]

Although the newly freed blacks were not allowed the right to vote under the Virginia Constitution of 1850, the legal rights of blacks were determined in the Freedman's Courts established all over the Southern states after the war. In 1867, the U.S. Congress passed the Reconstruction Act, which gave freedmen the right to vote for candidates to a convention to revise the Virginia Constitution.

Charlottesville was incorporated as an independent city in 1888, with a population of about 6,000. In 1889, the assessed value of all property in Charlottesville was $30,000. Charlottesville was in some ways a fairly modern city. The Charlottesville and University Gas Light Company, the first local gasworks, had been established in 1855. A steam laundry was introduced in 1886 and an ice plant in 1889. Street signs had been installed in 1866, but there were no paved streets. That didn't happen until 1895, when the city council voted to grade, curb and macadamize Main Street. The first water system was built in 1885, but there was no sewer system, and privies were in common use. The first city streetcar in 1887 was horse drawn and ran from the C&O terminal on the east side of the town to Anderson's corner

at the university. In the 1890s came steam-driven streetcars and then electric streetcars. In 1914, the first gasoline-powered omnibus ran out to Preston Heights, near the university.

PROFFIT

Proffit (initially called Egypt, then Bethel, then Proffit, after the man who owned the land on which the train station was sited) has been called "a rare survivor of the black communities established in Albemarle County after the Civil War, but which have largely disappeared or been rebuilt."[89] The town is now the center of the Proffit Historic District (NRHP, VLR).

From the early 1870s to 1881, this was a residential area for newly freed blacks. In the early 1870s, Ben Brown and John Coles purchased seventy-five acres of land from W.G. Carr, by whom they had formerly been enslaved. In 1876, Ned Brown purchased another seventy-five acres. Ned Brown subdivided his land and sold smaller plots to other black families. Not until 1881, when the Southern Railway established a train station here, did white families come to live in Proffit. The town then became a prosperous railway depot with a population of about twenty families, a status lasting until the 1930s and 1940s, when road improvements made it easier to drive the short distance to Charlottesville rather than take the train.[90] In the early twentieth century, Proffit was the site of the Ohio Sulphur Mining Company's operation, the only sulphur mine in Virginia. The mines were closed in the 1920s.

Many of the original houses in Proffit, built primarily from 1880 to 1900, are fallen down or in very poor condition, but some of the larger structures remain. In 1915, the first postmaster of Proffit, Elijah Cox, built a large two-story frame house called Lydia for his daughter, Lydia Viola Cox Leake, upon her marriage. Mrs. Leake lived in this house until her death in the late 1980s. The house is on the west side of the railroad tracks, on the north side of Proffit Road (Route 649), and is marked with a sign.

Located on the east side of the railroad tracks, and also north of Proffit Road, is the one-story, gable-roofed Evergreen Baptist Church, which was built by a black congregation in 1891. Notable features are a two-story tower, a steeple and lancet-arched windows. Next to Evergreen Church is Mossing Ford Road, a Revolutionary-era road that once led to James Minor's mill (now called Burnt Mills) on the South Fork of the Rivanna River.

An excellent website offering oral and documentary history materials about Proffit is available at http://www.vcdh.virginia.edu/afam/proffit.

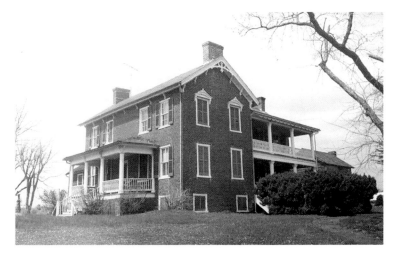

The Anchorage, Charlottesville, Virginia, date unknown. *Milton Waff Collection, Albemarle Charlottesville Historical Society, Charlottesville, Virginia.*

Tour—Southwest Albemarle

1. Arrowhead Farm

From Charlottesville, drive south on Monacan Trail Road (Route 29). Approximately four miles south of I-64, you will see Arrowhead Farm on a hill on your left. This was the home of Samuel Baker Woods, a son of the Reverend Edgar Woods who established Pantops Academy for boys. Samuel Woods was, in addition to serving as Charlottesville's mayor in the 1890s, an orchardist and farmer. The main house was built about 1840. (NRHP, VLR)

2. The Anchorage

Continue south on Route 29, and in five miles you will see the Anchorage high on a hill on your right, in a copse of trees. The brick and stone main house at Anchorage Farm was built about 1825, and has been the home of the Lewis and White families. The original house plan is two stories over a basement, with a hall and parlor configuration. In the middle of the nineteenth century, the north wing was added and the house remodeled into the then-popular Italianate and Gothic Revival styles. The property also includes an early twentieth-century barn and a family cemetery. (NRHP, VLR)

3. Inn at the Crossroads

http://www.crossroadsinn.com/

Continue south on Route 29 exactly 8.5 miles from I-64, and take a right onto Plank Road (Route 692). This intersection is North Garden, a historic rural community. One-tenth of a mile on your right is the Inn at the Crossroads (NRHP, VLR). Located on the Staunton-James

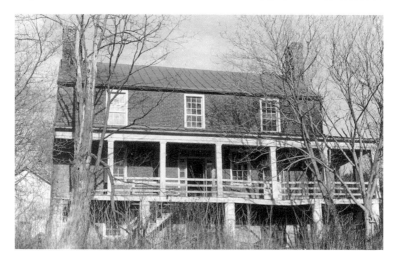

Tavern at the Crossroads, North Garden, Virginia, date unknown (prior to renovation as Inn at the Crossroads). *Milton Waff Collection, Albemarle Charlottesville Historical Society, Charlottesville, Virginia.*

River Turnpike, this old inn was built in 1818 and was originally called the Crossroads Tavern. It is a two-story structure with a two-story porch running the length of the building, as was common for taverns of this era. The building has been renovated and is currently in business as an inn.

4. ALBEMARLE COUNTY FAIRGROUNDS
http://www.albemarlecountyfair.com/
Continue west on Plank Road about a quarter of a mile. On your right is the site of the Albemarle County Fair, held every July (the rest of the year it is a cow pasture!).

5. BATESVILLE HISTORIC DISTRICT
Plank Road goes through the Batesville Historic District (NRHP, VLR) at the intersection with Miller School Road (Route 635). Batesville is one of the earliest surviving crossroads communities of Albemarle County, sited halfway between Staunton and Scottsville at the intersection of the Staunton–James River Turnpike and Dick Woods Road, an early connector to the Three Notch'd Road. This area was first known as Oliver's Store, from about 1760 to 1829. In 1829, the post office at this crossroads was called Mount Israel. Sometime between 1829 and 1835, the village was renamed for the Bates family that lived in the area.

Although the buildings in Batesville range from mid-eighteenth century to twenty-first century, most are from the turn of the twentieth century, and are in a simplified, vernacular style. As you drive through the town (watch the speed limit!), notice the following buildings:

MOUNTAIN VIEW BAPTIST CHURCH (6502 PLANK ROAD) is on your right just outside the town limits. The wood-frame church was constructed circa 1907–09. The original section has a stone foundation and a steeple.

PAGE'S STORE (6624 PLANK ROAD). The west section was built about 1900 and is still used as a store. It is a one-and-a-half-story, wood-frame house with a standing-seam metal roof. The east section is the more modern section and houses the Batesville Post Office.

ROSE M. PAGE HOUSE (6627 PLANK ROAD) is across the street from Page's Store. It was originally built about 1900 in the Folk National style, and was converted to a residence in 1945. This is a two-story, wood-frame house with a stone foundation.

Turn south onto Craigs Store Road (Route 635).

WOODLEA (1506 CRAIGS STORE ROAD) is a Classical Revival structure built in 1902. The most prominent feature of the house is a two-story portico with paired Corinthian columns and a fanlight in the pediment.

CASTLEBROOK (1521 CRAIGS STORE ROAD) is another Classical Revival brick house just past Woodlea on the left. The house was built in 1903.

MOUNT ED BAPTIST CHURCH (1606 CRAIGS STORE ROAD) is a brick Greek Revival church built 1856–57. The building has a pedimented front façade with brick pilasters. The congregation was established in 1788.

Returning to Plank Road, you will pass a number of Folk Victorian houses from the 1900–20 period.

BATESVILLE UNITED METHODIST CHURCH (6670 PLANK ROAD) is a brick structure built in 1861. It is noted as a representative sample of Greek Revival church design.

GEORGE W. GREEN HOUSE (6706 PLANK ROAD). This house was built in two phases, the west section about 1830 and the east section about 1880. It is two stories tall, with weatherboard siding and an enclosed front porch.

BROOKS-MARTIN LOG HOUSE (6716 PLANK ROAD) is a two-and-a-half-story log cabin, built about 1820.

6. BROOKSVILLE

After passing through Batesville, follow Plank Road until it intersects with Rockfish Gap Turnpike (Route 250). The community of Brooksville is situated on the north side of Route 250 at this point (though it is only a few houses now and isn't visible from the highway), and it was in Brooksville that General Custer stopped on the night of March 2 after the defeat of Early's army outside of Waynesboro.

7. LEBANON PRESBYTERIAN CHURCH

Turn right onto Route 250. A third of a mile east, on the north (left-hand) side of Route 250, is the Lebanon Presbyterian Church. This church was

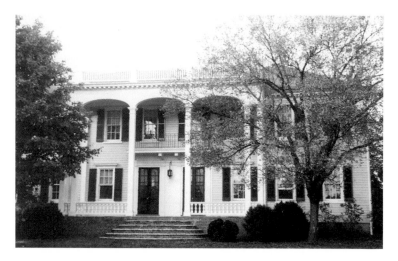

Ramsay, Greenwood, Virginia, date unknown. *Milton Waff Collection, Albemarle Charlottesville Historical Society, Charlottesville, Virginia.*

established in 1747 as the Mountain Plain Church, sponsored by the Woods and Wallace families of Woods' Gap. The church reorganized under the new name in 1824, and built upon the new site in the 1850s.

8. GREENWOOD ESTATES

As you continue east on Route 250, you will pass a number of farms and estates in the Greenwood area. Among them are:

RIDGELY FARM, built in 1903.

RAMSAY, a Classical Revival house built circa 1900. This was the home of Mr. and Mrs. Charles Dana Gibson. Mrs. Gibson, the former Irene Langhorne, lived here until her death in 1956. Mr. Gibson was the noted artist who drew the "Gibson Girls," modeled upon Mrs. Gibson. The house was renovated in the mid-twentieth century by architect Milton Grigg, who was known for his restoration work. (NRHP, VLR)

EMMANUEL EPISCOPAL CHURCH, established in 1860. The original church was built in 1862–63. The bell tower was given to the congregation by the Langhorne family in 1905. The current church, an expanded version of the original, was built in 1914, also sponsored by the children of Nancy Witcher Langhorne. (NRHP, VLR)

CASA MARIA, built in 1921–22 in the Spanish-Mediterranean style, with a 1928 addition. The gardens of Casa Maria are the design of Charles F. Gillette, one of the premier landscape architects in Virginia in the early part of the twentieth century. The original house is also attributed to Gillette, and if the attribution is true, it is the only known Gillette house in Virginia. (NRHP, VLR)

MIRADOR, built in 1842, was the home of the family of Chiswell Dabney Langhorne. The original Federal-style house is two stories high, with flanking one-story wings added in 1897. The house was renovated

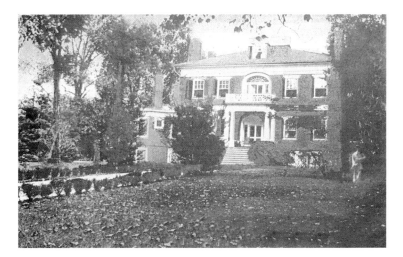

Mirador, home of the Langhorne family, postmarked 1912 (L.M. Joy Co.).
Collection of J. Tracy Walker III, Charlottesville, Virginia.

in a Georgian Revival style by architect William Adams Delano in the 1920s. In the late nineteenth century, the five Langhorne sisters of Mirador were famous for their beauty. Most famous were Irene and Nancy; Irene married illustrator Charles Dana Gibson in 1895, and became famous as the "Gibson Girl," the standard of beauty of that period. Nancy married, as her second husband, Waldorf Astor, later the second Viscount Astor, and made history by becoming the first female member of Parliament. (NRHP, VLR)

SEVEN OAKS FARM AND BLACK'S TAVERN, formerly known as Clover Plains (NRHP, VLR). The house and outbuildings are not visible from the highway, but are historically significant. Black's Tavern, a log cabin built by Samuel Black about 1769, was a well-known tavern on the Rockfish Gap Road (later Turnpike). The main residence was built 1847–48. The farm also has a number of other well-preserved nineteenth-century farm buildings, as well as an eighteenth-century smokehouse and an octagonal icehouse.

LONGHOUSE, built about 1840, was originally Yancey's Tavern, the last tavern built on the Rockfish Gap Turnpike.

THE CEDARS (NRHP, VLR) was built in the early 1850s by Colonel John S. Cocke. The house is built in the Greek Revival style. The property has at various times served as a boys' school, a Civil War hospital, a tannery and a casino. This site was the original location of Yancey's Mill and Mays Tavern, run by Colonel Charles Yancey, but no traces of the older buildings remain.

9. YANCEY MILLS

Continue east on Route 250. After crossing under the I-64 overpass, you will see Hillsboro Lane on your left. Turn left here and then make

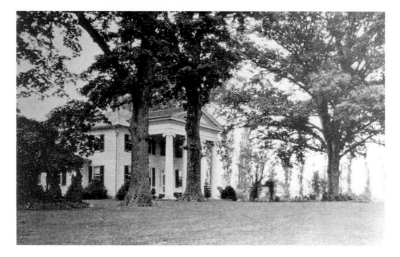

Seven Oaks (formerly Clover Plains), Greenwood, Virginia, date unknown.
*Milton Waff Collection, Albemarle Charlottesville Historical Society,
Charlottesville, Virginia.*

another immediate left. The Yancey's Mill Post Office was originally on
the Cedars property, but was moved two miles farther east to the village
of Hillsboro, which was renamed Yancey Mills. This community dates
back to 1748, and until World War II, was a commercial center. Along
this short lane are a number of early houses, including #6334, built
about 1875; #6397, built around the end of the Civil War; #6483,
built in the late eighteenth century; and #6486, built about 1900.

10. KING FAMILY VINEYARDS
http://www.kingfamilyvineyards.com/
When you reach the end of Hillsboro Lane, turn right onto Half Mile
Road. About a mile north of Yancey Mills, on the left-hand side, is
King Family Vineyards. In addition to tours and tastings, the family
hosts the free Roseland Polo matches on Sundays from May through
October. (The house, however, is of modern construction.) Continue
north on Half Mile Road, and you will intersect with Jarman's Gap
Road (Route 691).

11. JARMAN'S GAP
Turn left onto Jarman's Gap Road (Route 691), then left again onto
Greenwood Road. Woods' Gap, later called Jarman's Gap, was possibly
the earliest crossing in the Blue Ridge Mountains, and followed the
route of an earlier deer or buffalo path. The road later became the
Three Notch'd Road and led east to Charlottesville. To approximate
the early settlers' experience, you can drive up Jarman's Gap Road
until you reach the gate at the boundary of the Shenandoah National
Park. Caution: This is a narrow dirt and gravel road that goes up a

steep mountain and may be difficult to negotiate in wet or icy weather. There is no protective railing on the outer edge of the road.

Michael Woods and his family crossed into Albemarle County across the Blue Ridge from the Shenandoah Valley in 1734, but did not register their claim until 1737. The Woods family called their home place Mountain Plains. In 1788, the home passed into the possession of the Blair family, and it is now called Blair Park. The house is located off Greenwood Road, but is not visible from the road.

Chiles' Peach Orchard (http://www.cartermountainorchard.com/) is also located at 1351 Greenwood Road.

12. Crozet

Take Jarman's Gap Road east, passing Half Mile Road and continuing until you reach the town of Crozet. Before 1876, this area was known as Waylands, named for Abraham Wayland, who owned most of the surrounding orchard land.

The town of Crozet was named for Claude Crozet (called "Claudius" Crozet in America), a French engineer who served as state engineer of Virginia. During his two terms as state engineer, Crozet helped construct the Staunton–James River Turnpike to Scottsville and the Rockfish Gap Turnpike between Brooksville and Charlottesville. However, Crozet is most known for building the Blue Ridge Railroad from Mechum's River to Waynesboro, a seventeen-mile route that crossed the Blue Ridge Mountains and required the building of four tunnels, including the Blue Ridge Tunnel, the longest in the world at that time.

During the Civil War this railroad line was essential to move troops and supplies throughout the Confederacy. After the war, it became a way to move the produce of western Albemarle's orchards and vineyards to the rest of the country and the world. The Crozet depot started out as a flag stop for the Miller School on Route 635. In 1876, Abraham Wayland led a group of residents of western Albemarle in asking the C&O to establish a station to serve the western part of the county to make it easier to ship their apples and peaches. Everyone expected the name of the new depot to be Waylands, but Colonel William C. Wickland, former Confederate officer and general manager of the C&O, named the station after the engineer of the Blue Ridge Railroad, saying, "The name will be Crozet or nothing." In 1890, the Wayland family had established the first commercial orchard near Crozet.

Tour—West Main Street, Charlottesville

This driving tour starts on Vinegar Hill on the west end of Charlottesville. Vinegar Hill was the site of a flourishing black community that extended into the area between the town and the university. Though the buildings themselves were razed by an urban renewal project in the 1970s, Vinegar Hill remains alive in the memories of its residents.

Charlottesville Public School, circa 1904–08 (Leighton & Valentine). *Collection of J. Tracy Walker III, Charlottesville, Virginia.*

1. *Their First View of the Pacific*

Starting at the Omni Hotel, drive south on McIntire Road until you reach the intersection with West Main Street. On an island in the middle of this intersection is another of the statues donated to the city by Paul Goodloe McIntire. *Their First View of the Pacific* depicts explorers William Clark (front) and Meriwether Lewis, with the Indian woman Sacagawea crouching behind them. This statue is by Charles Keck, who also designed the pink granite pedestal. It was presented to the city on November 21, 1919. The statue sits in a remnant of Midway Park; the Civil War Midway Hospital was located on the elevated property to your left as you face south toward the statue. Charlottesville Public School was later located on the site of the hospital. (NRHP, VLR)

2. Mount Zion Baptist Church (105 Ridge Street)

Continue across West Main Street; at this point McIntire Road becomes Ridge Street. On your right behind the bus station is Mount Zion Baptist Church. Organized in 1867 as Mount Zion First African Baptist Church, their first pastor was the Reverend Spottswood Jones, also the first black pastor of a church in Charlottesville. The current church, built in 1884, was the second to be built on the site. (NRHP, VLR)

3. New Jefferson School (233 Fourth Street Northwest)

Backtrack to West Main Street and turn left (west). Turn onto Fourth Street Northwest (the first street on your right), and look to the west side of the street. The first African American school on this site, Jefferson Colored Graded/Elementary School, was built in 1894 in the area that is now the parking lot, and demolished in 1959. The current

building is the New Jefferson School, the oldest part of which was built here in 1926 to serve as a high school for the black population of the city during the period of segregated public education. Additions were made in 1938–39, 1958 and 1959. The school is situated in Starr Hill, a historically black neighborhood. The building is no longer used as a school, but as the Carver Recreation Center.

Go back to West Main Street and drive west two blocks.

4. Albemarle Hotel/Gleason Hotel (611 West Main Street)

In 1890, Michael Gleason built the Gleason Hotel on this site near the Train Station. This was a traveler's hotel, known for its restaurant and tea room. It was very popular until the Monticello Hotel opened in 1925. The hotel changed hands and was renamed the Albemarle Hotel in 1935. (NRHP, VLR)

5. First Colored Baptist Church/First Baptist Church (632 West Main Street)

On the south side of the street, on the corner of West Main and Seventh Street Southwest, you will see the First Colored Baptist Church. During the antebellum period, black members of Charlottesville's First Baptist Church were allowed to sit in the gallery and worship. On March 6, 1863, after the Emancipation Proclamation, eight hundred black members petitioned to be allowed to start their own church, and the request was granted. Initially holding separate services in the First Baptist Church building downtown, the congregation split into First Colored Baptist and Mount Zion Baptist Church (see number 2 above). The first group acquired the old Delevan Hotel, which was torn down in 1876 in order to build the new church. The church was completed in 1883. (NRHP, VLR)

6. Train Station (810 West Main Street)

Continuing west on West Main Street, just past the First Baptist Church is the train station, built in 1885 to serve, among others, the Southern Railway and the Chesapeake and Ohio Railway. It was recently renovated and has a sports bar on the second floor called Wild Wing Café.

7. Sally Hemings and Roosevelt Brown

Continue west on West Main Street, to Roosevelt Brown Boulevard (the Ninth-Tenth Street Connector). The corner on which the Hampton Inn and Suites now stands is locally believed to be the site of the house where Sally Hemings lived from the time of Thomas Jefferson's death in 1826 to her own death in 1835.[91] The street in front of the hotel is named in honor of Roosevelt Brown Jr., who played right tackle for the New York Giants from 1953 to 1965 and is the only person from Charlottesville in the Football Hall of Fame.

Albemarle Hotel (formerly the Gleason Hotel), circa 1935 (W.T. Walp).
Collection of J. Tracy Walker III, Charlottesville, Virginia.

8. WERTLAND STREET HISTORIC DISTRICT (NRHP, VLR)
As Roosevelt Brown Boulevard crosses West Main Street, it becomes
Tenth Street Northwest. Turn right at this light onto Tenth Street
Northwest. Go one block, then at the traffic light turn west onto
Wertland Street. Wertland Street is named after the second librarian of
the university, William Wertenbaker, who was appointed to his position
by Thomas Jefferson. Originally comprising four large tracts, the area
was subdivided for homes in the 1880s. The architecture is primarily

vernacular Victorian, although there are other styles represented. Though the exteriors have retained the original styles, many of these homes have been subdivided into student apartments.

1201 WERTLAND STREET (McKennie-Miller House) was the home of C.P. McKennie, the publisher of Charlottesville's first newspaper, the *Central Gazette*. The house was built about 1842.

1212 WERTLAND STREET (Georgia O'Keefe House). The family of artist Georgia O'Keefe moved to Charlottesville in 1909 and lived in this house. In 1912, O'Keefe enrolled in the University of Virginia Summer School and took drawing classes with Alon Bemont. (The university's summer sessions were open to women at that time, unlike the regular fall and spring sessions.) From 1913 to 1916, O'Keefe herself taught drawing in the summer school.

Wertenbaker himself lived in 1301 WERTLAND STREET, constructed in 1830 in the Federal style. The house originally fronted on West Main, and Thirteenth Street was the driveway to the house.

As you turn left from Wertland Street onto Fourteenth Street Northwest, note 201 FOURTEENTH STREET NORTHWEST, a two-story, wood-frame Victorian house built about 1875, and decorated with elaborate embellishments.

9. GEORGE ROGERS CLARK STATUE

Return to West Main Street via Fourteenth Street Northwest, and turn left at the traffic light. (Note: If you turn right here, toward the university, please note that the railroad bridge crossing West Main at this point is very low. Pay attention to the warning sign before taking a vehicle more than ten feet in height under this bridge.) Go one block east. If you look to your right on this block, you will see a triangular park with a statue in it, given to the university by—you guessed it— Paul Goodloe McIntire.

The George Rogers Clark Statue and its pedestal are by Robert Aitken, and depict a seven-figure group, in which the central focus is on Clark and an Indian chief to whom he is speaking. George Rogers Clark, the elder brother of William Clark, was sent on a mission by Virginia Governor Thomas Jefferson in 1781 to prevent the British from taking control of the Ohio Valley, also called the Old Northwest Territory. McIntire presented it to the University of Virginia on November 3, 1921, and it sits in this small park at the intersection of West Main Street and Jefferson Park Avenue (JPA). This work won the Watrous Medal from the National Academy of Design for Aitken in 1921, and was considered by artists of the time to be the best of the four McIntire-sponsored statues in Charlottesville and one of the great sculptural bronzes in America.

10. UNIVERSITY HOSPITAL

At the corner of West Main and JPA, turn right onto JPA. You will go past the University Hospital, with the old hospital on your right and

the new hospital on your left. The central, multi-story section of the old hospital was built in the 1950s, and it is surrounded by hospital buildings from the early twentieth century. The new hospital began serving patients in 1989.

11. LA MAISON FRANÇAISE (1404 JEFFERSON PARK AVENUE)

After you pass under the second walkway between the old and new hospitals, just past the traffic light, look to your left. You will see a huge Queen Anne–style brick house built in 1896 by Dr. Paul Barringer. The house was renovated in 1984 and serves as La Maison Française, a student residence in which only French is spoken.

12. FRY'S SPRING

Follow JPA west and pass two more traffic lights. At the fourth light, JPA will turn left as Emmett Street forks to the right. Follow JPA to the left. In another mile, JPA will intersect with Fontaine and Maury Avenues. At this intersection, follow JPA to the left.

Fry's Spring was the site of three healing springs, known to and used by the native tribes of the area. This property was settled by the Fry family (descended from Joshua Fry, early Albemarle surveyor and friend of Peter Jefferson), who gave the springs to the city of Charlottesville. As far back as the 1850s, Charlottesvillians were drinking the water in Fry's Spring as a tonic. Although visitors may still visit the springs, they are no longer used as a source of drinking water.

13. WHITE CROSS (214 STRIBLING AVENUE)

Pass over the railroad tracks and turn right onto Stribling Avenue. In 1890, the Jefferson Park Hotel and Land Improvement Co. advertised a planned community at Fry's Spring, but much of the design was never carried out. Steven Price Maury, UVA grad and descendant of the local Maury family, was the leader in this land company. He married well in San Antonio, Texas, returned rich to Charlottesville and bought Fry's Spring land. Also in 1890, he was deeded property in the area by his father, Jesse Lewis Maury of Piedmont, and built White Cross (later called Huntley Hall) in the Shingle style popular at the time. The two-story house at 214 Stribling Avenue is built of fieldstone and has a three-story circular tower, decorated with a cross of white stones built into the tower wall. The house is on the left side of the street as you go south, and may be difficult to see through the surrounding trees. (NRHP, VLR)

14. FRY'S SPRING BEACH CLUB (2512 JEFFERSON PARK AVENUE)

Return to JPA and turn right. In 1891, the Fry's Spring Railroad, "the Dummy Line," a narrow-gauge steam railroad, began operations out to Fry's Spring. In 1892, a hotel originally called the Hotel Albemarle (later called the Jefferson Park Hotel) was built at Fry's Spring where the Jefferson Park Baptist Church is now. In 1893, the steam railroad broke

Jefferson Park Hotel, Fry's Spring, circa 1905–10. *Collection of J. Tracy Walker III, Charlottesville, Virginia.*

down and was never reopened. The next year the first electric streetcar began operations in Charlottesville. In 1895, the streetcar company bought the Jefferson Park Hotel and the land. The center islands on this length of JPA indicate the route of the streetcar to Fry's Spring.

This area was a very popular resort in the late nineteenth and early twentieth centuries. A variety of events took place in the Fry's Spring area. In 1905, the Albemarle Horse Show Association developed a show grounds in this neighborhood and held annual summer shows here for about ten years. Over 16,000 people attended the two-day horse show in 1907. A 3,000-person auditorium was built for the purpose of hosting a Chautauqua during this period. Also in 1907, an amusement park called Wonderland opened across the street from the Jefferson Park Hotel (admission five cents), with an open-air dancing pavilion and a picnic grounds. Wonderland included billiards and pool parlors, vaudeville, a merry-go-round, roller skating and free moving pictures projected outdoors onto a bed sheet. These were probably the first motion pictures shown in the area.

The hotel burned in 1910, and what material could be salvaged was used to build houses in the area. One of those houses is still standing at 2712 Jefferson Park Avenue. In 1921, G. Russell Dettor built the current clubhouse of the Fry's Spring Beach Club and a public swimming pool (admission ten cents). As built, the pool holds almost a million gallons of water. This was the end of the city trolley line; the trolley turned around in the driveway of the club on JPA.

Read More About It

Ayers, Edward A. *The Promise of the New South: Life after Reconstruction.* New York: Oxford University Press, 1992.

Cimbala, Paul A., and Randall M. Miller. *The Freedmen's Bureau and Reconstruction.* New York: Fordham University Press, 1999.

Hunter, Robert F., and Edwin L. Dooley Jr. *Claudius Crozet: French Engineer in America, 1790–1864.* Charlottesville: University Press of Virginia, 1989.

Meeks, Steven G. *Crozet, a Pictorial History.* Crozet, VA: Meeks Enterprises, 1983.

Saunders, James Robert, and Renae Nadine Shackelford. *Urban Renewal and the End of Black Culture in Charlottesville, Virginia: An Oral History of Vinegar Hill.* Jefferson, NC: McFarland, 1998.

Wallenstein, Peter. *Cradle of America: Four Centuries of Virginia History.* Lawrence: University Press of Kansas, 2007.

Notes

Chapter 1

1. The fall line is a geographic boundary that runs from the falls of the Rappahannock River to the falls of the James River, near Richmond (roughly the route of I-95). The waterfalls are caused by the rivers moving from harder to softer bedrock, forming a zone separating the Piedmont from the Coastal Plain.

2. George Percy, *Observations Gathered out of a Discourse of the Plantation of the Southerne Colonie in Virginia by the English, 1606*. Virtual Jamestown, Virginia Center for Digital History, University of Virginia, http://etext.lib.virginia.edu/etcbin/jamestown-browse?id=J1002 (accessed February 26, 2007).

3. Ibid.

4. John Martin in a letter to the Virginia Company of London concerning the imprisonment of Edward-Maria Wingfield, in *Jamestown Narratives: Eyewitness Accounts of the Virginia Colony*, ed. Edward Wright Haile (Champlain, VA: RoundHouse, 1998), 189.

5. William Byrd, *The Westover Manuscripts…Written from 1728 through 1736* (Petersburg, VA: Printed by E. and J.C. Ruffin, 1841), 3.

6. Ivor Noel Hume, *Martin's Hundred* (Charlottesville: University Press of Virginia, 1991).

7. Lisa Rein, "Mystery of Virginia's First Slaves is Unlocked 400 Years Later," *Washington Post*, September 3, 2006, A1+.

8. *Werowance* is an Algonquin word meaning tribal chief or king. Inheritance of power was matrilineal in Powhatan society, thus Chief Powhatan's power descended to his brothers, then his sisters and then to the eldest son of his eldest sister, but never to the heirs of a male.

9. Anthony Chester, *Voyage of Anthony Chester to Virginia, Made in the Year 1620* (Leyden, the Netherlands: Peter Vander Aa, 1707), 209.

Chapter 2

10. Jeffrey L. Hantman, "Between Powhatan and Quirank: Reconstructing Monacan Culture and History in the Context of Jamestown," *American Anthropologist* new series 92, no. 3 (September 1990), 676–90.

11. Gabriel Archer, "A relatyon written by a gentleman of ye colony," in *The Jamestown Voyages Under the First Charter, 1606–1609*, ed. Philip L. Barbour, 2nd series, vols. 136–37 (London: Hakluyt Society, 1969), 80–98.

12. John Smith, *The Generall Historie of Virginia, New-England, and the Summer Isles* (London: Printed by I[ohn] D[awson] and I[ohn] H[aviland] for Michael Sparkes, 1624), 63, in *Early English Books Online*, http://gateway.proquest.com/openurl?ctx_ver=Z39.88-2003&res_id=xri:eebo&rft_id=xri:eebo:citation:99847142 (accessed February 26, 2007).

13. John Lederer, *The Discoveries of John Lederer, in Three Several Marches from Virginia, to the West of Carolina*, trans. Sir William Talbot (London: Printed by J.C. for S. Heyrick, 1672), http://rla.unc.edu/Archives/accounts/Lederer/Lederer.pdf (accessed February 27, 2007).

14. Ibid., 8.

15. Ibid., 23.

16. Ibid., 2.

17. Ibid., 3.

18. Ibid., 5.

19. Thomas Jefferson, *Notes on the State of Virginia* (London: printed for John Stockdale, 1787), 161–62, in *Eighteenth Century Collections Online*, http://galenet.galegroup.com/servlet/ECCO (accessed February 27, 2007).

20. Francis Makemie, *A Plain and Friendly Perswasive to the Inhabitants of Virginia and Maryland, for Promoting Towns and Cohabitation* (London: Printed by John Humfreys, 1705), 6.

21. There is a recent, alternate theory that holds that the crossing was made at Milam Gap, farther south.

22. Current usage seems to be "Three Chopt" east of Charlottesville and "Three Notch'd" west of Charlottesville. For the purpose of this guide, I will refer to the entire length of the road as "Three Notch'd."

23. The actual date in the Julian calendar in effect at the time was February 1744, since the year ran from March 25 through March 24 of the next year. However, in our current Gregorian calendar, the date is February 1745.

24. In 1777, Fluvanna County was split off from Albemarle, and in 1809 parts of Albemarle and Amherst were used to create Nelson County to achieve the current configuration of counties.

25. By 1745, the Mountain Ridge Road had been built from Woods' Gap (now Jarman's Gap) in the Blue Ridge Mountains to the D.S. tree next to the D.S. Tavern (near present-day Ivy), where it joined with the Three Notch'd Road from Richmond, and the entire length was renamed Three Notch'd Road. It was the main east-west thoroughfare in Virginia for two hundred years, until the road was replaced by State Route 250 and rerouted through Rockfish Gap.

26. There is some speculation that the architect was Benjamin Henry Magruder, who had a law practice in Scottsville before he purchased Glenmore near Shadwell in 1843.

27. Virginia Moore, *Scottsville on the James: An Informal History* (Charlottesville: Dietz Press, 1994), 87.

CHAPTER 3

28. Though the German soldiers were called "Hessians" by the Virginians, they were predominately "Brunswickers" in the service of the Duke of Brunswick.

29. John Burk and Louis Hue Girardin, *The History of Virginia, From the First Settlement to the Present Day* (Petersburg, VA: Printed for the author, by Dickson & Pescud, 1804–16), vol. 4, 323–28. John Burk died after finishing the first three volumes of his history, so the fourth volume was written by Louis Hue Girardin, an acquaintance of Thomas Jefferson. Girardin stayed at a farm near Milton, possibly Glenmore, while writing the volume, and was given access to Jefferson's papers and recollections in order to write the history of Virginia's role in the Revolution.

30. Peter Bacque, "Charlottesville Was Once the State Capitol," *Daily Progress (Charlottesville)*, November 16, 1975, C1–2.

31. Burk and Girardin, *The History of Virginia*, vol. 4, 323–28.

32. Thomas Anburey, *Travels through the Interior Parts of America. In a Series of Letters. By an Officer…* (London: Printed for William Lane, 1789), letters 62–72, vol. 2, 315–484, in *Eighteenth Century Collections Online*, http://galenet.galegroup.com/servlet/ECCO (accessed February 26, 2007). Anburey was imprisoned in Charlottesville in 1779–80, so his descriptions of the conditions of the prisoners are probably accurate, but he is known to have plagiarized from other writers on America in this work.

33. Ibid., vol. 2, 315–18.

34. Charlotte S.J. Epping, trans., "Journal of Du Roi the Elder, Lieutenant and Adjutant, in the service of the Duke of Brunswick, 1776–1778," in "Years of Hardships and Revelations: The Convention Army at the Albemarle Barracks, 1779–1781," Philander D. Chase, *The Magazine of Albemarle History* 41, 1983, 12.

35. Friederike Charlotte Luise, Freifrau von Riedesel, *Letters and Memoirs Relating to the War of American Independence, and the Capture of the German Troops at Saratoga* (New York: G.&C. Carvill, 1827), 215.

36. Anburey, *Travels*, vol. 2, 436.

37. Ibid., vol. 2, 439–40.

38. Philander D. Chase, "Years of Hardships and Revelations: The Convention Army at the Albemarle Barracks, 1779–1781," *The Magazine of Albemarle History* 41, 1983, 10–53.

39. In fact, British General Phillips, still the official commander of the Convention Army, apparently wanted to merge the Convention Army with the forces encamped in Portsmouth, a move that would result in a dangerous concentration of enemy forces in the center of the state. Richard Sampson, *Escape in America: The British Convention Prisoners, 1777–1783* (Chippenham, Wiltshire: Picton Pub., 1995), 125.

40. B.L. Rayner, "The British Invasion of Virginia," chap. 15 in *Life of Thomas Jefferson* (Boston: Lilly, Wait, Colman, & Holden, 1834; revised by Eyler Robert Coates Sr., 2001) http://etext.virginia.edu/jefferson/biog/index.html (accessed October 10, 2006).

41. Jack Jouett's father was John Jouett Sr., who at this time owned both a farm in Louisa County and the Swan Tavern in Charlottesville, and who may have been a former owner of Cuckoo's Tavern.

42. The evidence is conflicting here, but Jefferson's family seems to have first gone to Blenheim, the home of the Carter family, and then on to Enniscorthy, the Coles' plantation, where Jefferson joined them for an early supper.

43. Robert R. Howison, *A History of Virginia: From its Discovery and Settlement by Europeans to the Present Time* (Philadelphia: Carey & Hart, 1846–48), vol. 2, 270–71.

44. Virginia General Assembly, House of Delegates, *Journal of the House of Delegates, May 8 to June 23, 1781* (Charlottesville: Printed by John Dunlap and James Hayes, printers to the Commonwealth, 1781), 21–22, in *Archive of Americana, Early American Imprints*, Series

I: Evans, 1639–1800, http://infoweb.newsbank.com/iw-search/we/Evans/ (accessed January 18, 2007).

45. The Jouett home in Versailles, Kentucky, is open for tours. See http://www.jackjouetthouse.org/. Another interesting connection is that Jack Jouett's wife was Sally Robards, the sister of Lewis Robards, who was the first husband of Rachel Donelson. Rachel later married Andrew Jackson, who became a president of the United States.

Chapter 4

46. John Hammond Moore, *Albemarle, Jefferson's County, 1727–1976* (Charlottesville: Albemarle County Historical Society, 1976), 99–100.

47. Agricultural fairs were again held in Albemarle County in the post–Civil War years, including the James River Valley Fair held at Scottsville from 1883 to about 1890; an "Afro-American county fair" in 1891; and the Albemarle County Fair and the Greater Piedmont Fair of the early twentieth century. The Albemarle County Fair was again revived in 1981 and continues to be held each summer at North Garden, eleven miles south of Charlottesville.

48. In the early nineteenth century the American Colonization Society led a movement to "repatriate" American blacks to Africa. Settlement of the colony of Liberia began in 1822, and in 1847 the colony declared itself an independent state. The capital of the country is Monrovia, which was named after Albemarle resident James Monroe, who was president at the time Liberia was settled. Approximately 3,700 freed slaves from Albemarle County immigrated to Liberia from 1822 to 1861.

49. Moore, *Albemarle*, 124.

50. Thomas Jefferson, discussing the Missouri question and slavery, to John Holmes, April 22, 1820, in *Thomas Jefferson on Politics & Government*, http://etext.virginia.edu/jefferson/quotations/jeff1290.htm (accessed March 20, 2007).

51. Minnie McGehee, "Rivanna River Navigation Improvements Started on an Organized Scale in 1805," *Daily Progress*, August 15, 1966, A3.

52. Kay Collins Chretien, "Happenings in the Horseshoe Bend," *Charlottesville Home*, January 1993, 4. The road follows Route 20 to Keene, westward through North Garden on Route 712 to Route 692, then through Batesville to its junction with Route 250 at the foot of Afton Mountain.

53. William S. White, *Rev. William S. White, D.D., and His Times* (Richmond: Presbyterian Committee of Publication, 1891), 91. White was for a time the pastor of the Scottsville Presbyterian Church before settling in Charlottesville and starting the Charlottesville Female Academy in the Old Manse.

54. Thomas Jefferson to Dr. Thomas Cooper, September 1, 1817, *The Modern English Collection*, University of Virginia Electronic Text Center, http://etext.virginia.edu/toc/modeng/public/JefCoop.html (accessed November 19, 2006).

55. Sarah N. Randolph, *The Domestic Life of Thomas Jefferson* (New York: Harper & Brothers, 1871), 390–91.

56. Though some accounts incorrectly state that President Monroe was present in the carriage, Monroe was in Washington, D.C., at a session of Congress.

57. Philip Alexander Bruce, *History of the University of Virginia, 1819–1919* (New York: Macmillan Company, 1920–22), vol. 2, 329–33, and vol. 4, 322–23.

58. *A complete history of the Marquis de Lafayette, major-general in the American army in the war of*

the revolution. Embracing an account of his tour through the United States, to the time of his departure, September, 1825, by an officer in the late army (Columbus, OH: J. & H. Miller, 1858), 141; Henry Stephens Randall, *The Life of Thomas Jefferson* (New York: Derby and Jackson, 1858), vol. 3, 504.

59. Robert D. Ward, *An Account of General La Fayette's Visit to Virginia in the Years 1824–25* (Richmond: West, Johnston & Co., 1881), 88–97.

60. George Tucker, *The Life of Thomas Jefferson* (Philadelphia: Carey, Lea & Blanchard, 1837), vol. 2, 478–79.

61. James Alexander, *Early Charlottesville: Recollections of James Alexander, 1828–1874* (Charlottesville: Virginia National Bank, 1963), 15.

62. Ibid., 16–17.

63. Paul Forrest Jones, "Halloween Mystery: 99 years later, the McCue murder," *The Hook* no. 243 (October 30, 2003) http://www.readthehook.com/Stories/2003/10/30/coverHalloweenMystery99Yea.html (accessed April 20, 2007).

64. From 1825 until 1904, the University of Virginia was run by the faculty under the governance of the rector, the Board of Visitors (the governing board) and the chairman of the faculty. In 1904, Edwin Anderson Alderman was appointed the first president of the university.

CHAPTER 5

65. Macadam was a method of surfacing roads that was invented by John McAdam about 1820. The method consisted of spreading layers of stones on a prepared roadbed and compacting each layer with a heavy roller. Macadamization was popular until automobiles came into use.

66. Edith Louise MacDonald, "I Hope and Wait: the journal of Louisa Minor, Charlottesville, Virginia, 1855–1866" (masters thesis, University of Central Florida, 1991), 100; Ervin L. Jordan Jr., *Charlottesville and the University of Virginia in the Civil War* (Lynchburg, VA: H.E. Howard, 1988), 22.

67. Ervin L. Jordan Jr. and Herbert A. Thomas Jr., *Nineteenth Virginia Infantry* (Lynchburg, VA: H.E. Howard, 1987); "The Early Days of the War," *The Magazine of Albemarle County History* 22, 1963–64, 7–13.

68. Chalmers L. Gemmill, "The Charlottesville General Hospital 1861–1865," *The Magazine of Albemarle County History* 22, 1963–64, 104.

69. "Stonewall Jackson's Body Passes Through Charlottesville," *The Magazine of Albemarle County History* 22, 1963–64, 22.

70. George A. Custer, "Report, March 1, 1864, near Madison Court-House," in *The War of the Rebellion*, United States War Department (Washington, D.C.: Government Printing Office, 1891), series 1, vol. 33, 161.

71. Marcellus N. Moorman, "Report, March 4, 1864," in *The War of the Rebellion*, United States War Department (Washington, D.C.: Government Printing Office, 1891), series 1, vol. 33, 167–68.

72. Mary Garrett lived at Clover Plains (now called Seven Oaks), an estate about fifteen miles west of Charlottesville. The closest train station was Greenwood.

73. Mary Randolph Garrett to Lucia Cary Harrison Blain, March 3–4, 1865, in "'Oh Luce': a Young Lady Experiences the Union Army Invasion of Albemarle, March 1865," Robert Blain Scheele, *The Magazine of Albemarle County History* 61, 2003, 84–85, 92.

74. In 1865, Carr's Hill was topped by a collection of dormitory structures for the students.

75. Anne Freudenberg and John Casteen, eds., "John B. Minor's Civil War Diary," *The Magazine of Albemarle County History* 22, 1963–64, 49.

76. Egbert R. Watson, "Letter to His Daughter, Mrs. Henry Smith," *The Magazine of Albemarle County History* 22, 1963–64, 41.

77. "General Custer at Piedmont," *The Magazine of Albemarle County History* 22, 1963–64, 75.

78. Anne Freudenberg, "Sheridan's Raid, an account by Sarah A.G. Strickler," *The Magazine of Albemarle County History* 22, 1963–64, 60.

79. Wesley Merritt, "Report, May 7, 1865," in *The War of the Rebellion*, United States War Department (Washington, D.C.: Government Printing Office, 1894), series 1, vol. 46, 486.

80. This bridge was not rebuilt until late November 1866, leaving the ferry as the only way to cross the river in the interim.

81. Alfred Gibbs, "Report, March 21, 1865," in *The War of the Rebellion*, United States War Department (Washington, D.C.: Government Printing Office, 1894), series 1, vol. 46, 500.

82. Court Van Clief, "Scottsville Burned by War Between the States: Gen. Sheridan's Raid," *Scottsville Monthly*, August 2003, 17–18.

83. Benjamin Brown and his wife, Sarah, had eleven children, eight of them boys: Benjamin Jr., Barzillai, Benajah, Bernard, Bernis, Bezaleel, Brightberry and William. The girls were named Elizabeth, Lucretia and Agnes. Benjamin Jr. built the first Brown house near this end of Browns Gap Turnpike, and called it "Headquarters."

84. Courtney Stuart, "Colridge was Kenridge: And Rinehart's gold left a mixed legacy," *The Hook* no. 329 (July 29, 2004) http://www.readthehook.com/Stories/2004/07/28/coverColridgeWasKenridgeAn.html (accessed April 20, 2007).

CHAPTER 6

85. Moore, *Albemarle*, 214–15.

86. W.W. Waddell, "Charlottesville in 1875," *Papers of the Albemarle County Historical Society* 2 (1941–42), 5–8.

87. Joseph C. Vance, "Race Relations in Albemarle during Reconstruction," *The Magazine of Albemarle County History* 13, 1953, 42.

88. The schools in Virginia were, by law, segregated by race until the late 1950s.

89. "Proffit Historic District National Register of Historic Places Nomination Form" (Washington, D.C.: U.S. Department of the Interior, National Park Service, 1998), section 8, 12.

90. The fare to ride the train from Proffit to Charlottesville was seventeen cents in the early twentieth century.

91. Sally Hemings was never legally freed upon Jefferson's death and remained enslaved to the Jefferson family for the rest of her life. However, historians speculate that she was "given the use of her time" by Jefferson's daughter Martha Randolph, which was an unofficial way to free a slave, and allowed her to remain in Virginia. Sally lived with her sons Eston and Madison until her death.

Please visit us at
www.historypress.net